BFI Film Classics

The BFI Film Classics is a series of books that introduces, interprets and celebrates landmarks of world cinema. Each volume offers an argument for the film's 'classic' status, together with discussion of its production and reception history, its place within a genre or national cinema, an account of its technical and aesthetic importance, and in many cases, the author's personal response to the film.

For a full list of titles available in the series, please visit our website: www.palgrave.com/bfi

'Magnificently concentrated examples of flowing freeform critical poetry.'
Uncut

'A formidable body of work collectively generating some fascinating insights into the evolution of cinema.'
Times Higher Education Supplement

'The series is a landmark in film criticism.'
Quarterly Review of Film and Video

'Possibly the most bountiful book series in the history of film criticism.'
Jonathan Rosenbaum, *Film Comment*

Editorial Advisory Board

Geoff Andrew, British Film Institute
Edward Buscombe
William Germano, The Cooper Union for the Advancement of Science and Art
Lalitha Gopalan, University of Texas at Austin
Lee Grieveson, University College London
Nick James, Editor, Sight & Sound

Laura Mulvey, Birkbeck College, University of London
Alastair Phillips, University of Warwick
Dana Polan, New York University
B. Ruby Rich, University of California, Santa Cruz
Amy Villarejo, Cornell University

The Gold Rush

Matthew Solomon

A BFI book published by Palgrave

© Matthew Solomon 2015

All rights reserved. No reproduction, copy or transmission of this publication may be made without written permission. No portion of this publication may be reproduced, copied or transmitted save with written permission or in accordance with the provisions of the Copyright, Designs and Patents Act 1988, or under the terms of any licence permitting limited copying issued by the Copyright Licensing Agency, Saffron House, 6–10 Kirby Street, London EC1N 8TS. Any person who does any unauthorised act in relation to this publication may be liable to criminal prosecution and civil claims for damages.

The author has asserted his right to be identified as the author of this work in accordance with the Copyright, Designs and Patents Act 1988.

First published in 2015 by
PALGRAVE

on behalf of the

BRITISH FILM INSTITUTE
21 Stephen Street, London W1T 1LN
www.bfi.org.uk

There's more to discover about film and television through the BFI. Our world-renowned archive, cinemas, festivals, films, publications and learning resources are here to inspire you.

Palgrave in the UK is an imprint of Macmillan Publishers Limited, registered in England, company number 785998, of 4 Crinan Street, London N1 9XW. Palgrave Macmillan in the US is a division of St Martin's Press LLC, 175 Fifth Avenue, New York, NY 10010. Palgrave is a global imprint of the above companies and is represented throughout the world. Palgrave® and Macmillan® are registered trademarks in the United States, the United Kingdom, Europe and other countries.

Series cover design: Ashley Western
Series text design: ketchup/SE14
Images from *The Gold Rush* (Charles Chaplin, 1925), © Roy Export S.A.S.; *The Rough House* (Roscoe Arbuckle, 1918), Comique Film Corporation; *The Kid* (Charles Chaplin, 1921), © Roy Export S.A.S.; *City Lights* (Charles Chaplin, 1931), © Roy Export S.A.S.; *The Blackbird* (Tod Browning, 1926), Metro-Goldwyn-Mayer Pictures Corporation; *Modern Times* (Charles Chaplin, 1936), © Roy Export S.A.S.; *The Pawnshop* (Charles Chaplin, 1916), Mutual Film Corporation; *The Sea Gull* (Josef von Sternberg, 1926), © Roy Export Company Establishment.

Set by Cambrian Typesetters, Camberley, Surrey
Printed in China

This book is printed on paper suitable for recycling and made from fully managed and sustained forest sources. Logging, pulping and manufacturing processes are expected to conform to the environmental regulations of the country of origin.

British Library Cataloguing-in-Publication Data
A catalogue record for this book is available from the British Library
A catalog record for this book is available from the Library of Congress

ISBN 978–1–84457–640–1

(*previous page*) Eddie Manson, Chaplin and Rollie Totheroh on location, 1924, © Roy Export Company Establishment

Contents

Acknowledgments	6
1 A Film in Flux	9
2 An Unstable Text	16
3 The Total Film-Maker	20
4 Origins and Originality	25
5 The Work of the Artist and His Lawyers in an Age of Technological Reproducibility	30
6 'The Lucky Strike'	39
7 A Northern Comedy	47
8 Historical Referents	57
9 Making by Halves; Two Premieres	65
10 Revising and Reviving	72
11 Second-Best Ever	78
12 Un/Authorised Versions	82
13 Memorable Sequences	87
14 Outtakes, Parallel Takes and a Triple Take	97
Notes	104
Credits	115
Select Bibliography	117

Acknowledgments

I have wanted to write one of these books ever since I read Peter Wollen's contribution to the BFI Film Classics series. I am grateful to the editorial advisory board for the series and Rebecca Barden for the opportunity. Several BFI Film Classics authors generously provided counsel – I am especially appreciative of supportive exchanges with James Naremore, Charles Maland and Sarah Kozloff. The comments I received from the anonymous review process were uniformly helpful. My sincere thanks also go to Jenna Steventon, Lucy Knight, Sophia Contento and Chantal Latchford, who helped prepare and publish the book.

Ben Strassfeld compiled much research for this volume while serving as a consistently helpful interlocutor during the process of research and writing; he travelled with me down the rabbit hole of multiple versions and into the thickets of copyright law with no hesitation. David Mayer directed me to nineteenth-century theatre sources and made possible the reproduction of a poster from his collection. The week I spent at the Cineteca di Bologna's Biblioteca Renzo Renzi viewing documents digitised from the Chaplin Archive proved to be the most memorable part of this project. Thank you to Cecilia Cenciarelli, Monia Malaguti, Andrea Dresseno and Cesare Ballardini for making my time in Bologna both productive and pleasant. I am also grateful to the Association Chaplin for permission to quote from documents in the Chaplin Archive and to reproduce images protected by copyright; Kate Guyonvarch and Arnold Lozano were extremely helpful and gracious in facilitating this process. Two multilingual research assistants, Amanda Getty and Yuki Nakayama, found a lot of interesting material, though most of it did not make it into the book in the end; Nic Heckner translated German sources. Writing this monograph was enriched by conversations with

THE GOLD RUSH | 7

University of Michigan colleagues Richard Abel, Giorgio Bertellini, Hugh Cohen, Caryl Flinn, Phil Hallman, Dan Herbert, Johannes von Moltke, Markus Nornes and John Whittier-Ferguson. Gillian Anderson, Alice Artzt, Jennifer Bean, Alice Birney, Andre Blay, Kevin Brownlow, Nico de Klerk, Paul Duncan, Scott Eyman, E. Hunter Hale, Charlie Johnston, Bruce Kirby, Kristine Krueger, Bruce Lawton, Vincent Longo, Luke McKernan, Liam Meisner-Driscoll, Page Miller, Wyatt Phillips, Mark Sandberg, Eli Savada, Melvyn Stokes, Yuri Tsivian, Jeffrey Vance and Roberto Vezzani each responded graciously and informatively to my requests and my queries. Any deficiencies of the book are of course mine.

For Margot.

Photograph by Jennifer Chapman, 2013

8 | BFI FILM CLASSICS

The Gold Rush 1925 poster, © Roy Export S.A.S., from the poster collection of the Margaret Herrick Library, Academy of Motion Picture Arts and Sciences

1 A Film in Flux

There was not just one *Gold Rush* – there have been many. Charlie Chaplin, the film's director and star, produced and released two different versions, a silent version in 1924–5 and a sound version in 1941–2. The sound version includes Chaplin's voiceover narration and a musical score that Chaplin wrote, along with a few sound effects and new title credits. Besides excising all of the intertitles and adding a synchronised soundtrack, which necessitated projection at a consistent rate of twenty-four frames per second rather than the slower speeds typically used to shoot and project films during the silent period, Chaplin also made a number of changes to the visual track. Chaplin tinkered with many parts of the film in preparing the sound version, substituting alternative takes – or different parts of the same take – by drawing from thousands of outtakes that remained in his vaults. United Artists re-released the sound version to theatres again in 1956, but in the interim, Chaplin neglected to renew copyright on the silent version. Since copyright on the silent version expired in the United States twenty-eight years after its release, it was part of the American public domain from 1953 until 1997, at which time its copyright was retroactively restored.[1] So, for most of the second half of the twentieth century, it was duplicated, distributed and re-duplicated on 8mm and 16mm film, videocassette and videodisc in dozens of different versions. As copies proliferated, so did its variations, many of which were derived from one or more of the versions already in circulation. None is exactly the same since changes were introduced with every new generation of copies and every transfer from one format to another. Some of the differences between versions are subtle – a slight shift in framing, the substitution of one take or camera angle for another, *nearly* identical shot – but others, like the addition or substitution of a soundtrack

and/or a change of speed, are far more noticeable.[2] Chaplin insisted that the seventy-two-minute sound version 'with music and words' was _The_ Gold Rush (hence its primacy – and formerly its exclusivity – on all video releases authorised by Chaplin's Roy Export Company). Audiences, however, have seen *The Gold Rush* in different versions in formats that have ranged from 35mm film to video files streaming online. Unlike fully 70 per cent of American silent feature films, which are now considered lost, *The Gold Rush* survives. Moreover, it is readily accessible – unlike most surviving silent feature films.[3] Copies abound, but many differ. Thus, it is truly a film of 'permutations'.[4]

'This is the picture I want to be remembered by', Chaplin said of *The Gold Rush* in 1925.[5] But, *how* the film is remembered depends partly on which version(s) one has seen and heard. There were at least three different versions screened for paying audiences in 1925 alone, which makes the conventional notation '*The Gold Rush* (1925)' somewhat unclear, especially since no complete print – much less a negative – of the film in any of the forms in which it was originally shown or distributed is known to survive. The sound version, *The Gold Rush* (1942), which has varied comparatively little since its theatrical release, is the 'director's cut', and Chaplin would have preferred that it were the *only* cut. In a legal statement made some time after 1956, Chaplin stated that following the '1942 revival' of *The Gold Rush*, he 'gave instructions that the 1925 silent version should no longer be shown and ordered the destruction of the original negatives, fine grains and prints thereof'.[6]

Like many features of the silent period, *The Gold Rush* was shot primarily with two cameras placed side by side – what one observer on the set of the film described as 'the two inseparable cameras'.[7] Chaplin's longtime cameraman Roland 'Rollie' Totheroh operated one of the cameras and Totheroh's assistant Jack Wilson generally operated the other. In daily production reports, the infrequent occasions when only one camera was used were specially noted, as were the even more infrequent occasions when four or six

cameras were used (for certain location shots and special effects).[8] Filming every take with two parallel cameras facilitated the creation of two negatives, something Chaplin had done since his 1917 contract with First National stipulated it.[9] This practice necessarily introduced slight variations in framing and speed between the negative shot with the A camera and the negative shot with the B camera. Each and every positive print struck from one of these negatives was also subject to further alterations by distributors, censors and exhibitors, as well as to later changes by collectors, archivists and re-distributors (some of whom combined footage from different prints), all while suffering the inevitable physical and chemical deterioration that occurs with projection and the passage of time.

From the moment Chaplin finished shooting *The Gold Rush*, it was a film in flux. According to daily production reports, the final shot of the film was taken on 21 May 1925. When *Variety* announced 'Chaplin's "Gold Rush" Completed', Chaplin said he was still unsure whether it would eventually be ten, eleven or twelve

Filming *The Gold Rush* with the customary two cameras in the Chaplin studios in 1925. (From left to right) Jack Wilson, Rollie Totheroh, Chaplin and Associate Director Chuck Riesner © Roy Export Company Establishment, scan courtesy of Cineteca di Bologna

12 BFI FILM CLASSICS

reels long.[10] Because Chaplin had edited parts of the film already (as was his practice), he was able to preview the film just one week after the last shot at the Forum Theatre in Los Angeles on 28 May 1925.[11] Another month later, following four more weeks of 'cutting and editing' recorded in daily production reports, *The Gold Rush* officially premiered on 26 June 1925 at Sid Grauman's Egyptian Theatre in Hollywood. At this point, the film was 9760 feet long (almost ten reels) and reportedly ran some 120 minutes.[12] Lita Grey (née Lillita MacMurray), who was Chaplin's co-star in the film before marrying him, recalled, 'He spent a long time – over two months – editing the film and cut a whole reel from it after the premiere'.[13] Indeed, by the time *The Gold Rush* had its New York premiere at the Mark Strand Theatre on 16 August 1925, it had been reduced to 8924 feet (nine reels) and ran 96 minutes.[14] Some felt it should have been even shorter, with Herbert Howe of *Photoplay* writing that *The Gold Rush* needed 'at least three dead

Lita Grey signed a contract on 2 March 1924 to co-star with Chaplin in his new comedy, © Roy Export Company Establishment

THE GOLD RUSH | 13

reels extracted before they affect the good ones'.[15] The version that was distributed in 1925 was abbreviated a bit further – though not by three reels – to the length of 8555 feet.[16]

In 1941, Chaplin returned to *The Gold Rush* to revive it as a synchronised sound film and planned to cut even more. He told *Variety* he was going to cut it 'down to 8,000 feet to increase its tempo' and promised ' "The Gold Rush" will be about 1,500 feet shorter than the original version' – although it is not clear which version he considered to be 'the original'.[17] On 21 December 1941, Chaplin previewed the revival at the United Artists theatre in Inglewood, California. He made sound retakes over the next few weeks and screened a final cut of the sound version on 12 January 1942 for the Motion Picture Producers and Distributors of America, immediately receiving MPPDA approval. The sound version premiered in New York at the

1942 poster

Globe Theatre on 18 April 1942 and in Hollywood at the Paramount Theatre on 19 May 1942. As released, *The Gold Rush* (1942) is 6462 feet, with a screen time of seventy-two minutes.[18] The length of the film allowed exhibitors to combine it with another feature to create wartime double bills: it was paired with *Blondie for Victory* (1942) in Oakland, California; with *Torpedo Boat* (1942) in Madison, Wisconsin and with *Sergeant York* (1941) in the state of New York.[19]

During the 1970s, when *The Gold Rush* was mainly available in silent 16mm film prints, Walter Kerr noted,

> I once closely examined three different prints of *The Gold Rush* ... to discover that in several sequences Chaplin had used alternate 'takes.' The chase through the Alaskan saloon, with Big Jim McKay trying to get his great paws on Charlie, exists in variant patterns.[20]

Close examination of versions that have circulated since that time reveals many such variant patterns, most of which were not a direct result of Chaplin's creative decisions, but instead are due to the interventions of others. In a careful comparison of versions of *The Gold Rush* on videocassette, Alice Artzt found striking differences in speed, musical accompaniment and visual quality as well as numerous subtle variations:

In some versions, the captain taps the officer with his left hand, but in others it is his right hand

In most cases the scenes are the same, even many small details are the same, but slight differences betray the fact that the takes are *not* the same – an extra flick of a finger, a slight pause, a slightly different series of movements, a different number of steps in a particular direction, a slightly different way of putting on a hat, etc.[21]

Some of these differences may have been introduced through the substitution of alternate takes (rather than parallel takes shot with the second camera) in preparing a second negative for international distribution. Additionally, Raymond Rohauer claimed to have used outtakes he acquired after the abrupt 1952 shutdown of Chaplin's studios for the unauthorised versions of *The Gold Rush* that he distributed.

2 An Unstable Text

In the introduction to his collection of Chaplin criticism, Richard Schickel writes of Chaplin's *Limelight* (1952), 'But a movie is also a text, concrete and unchangeable, and in the end we must deal with that – with what is on the screen before us'.[22] However, the 'text' of *The Gold Rush* has proven notoriously malleable and changeable – it has long been decidedly unstable. Indeed, I argue that *The Gold Rush* is better understood through the terms proposed by literary scholar Jack Stillinger: 'A *version* of a work is a physically embodied text of the work… . A *work* is constituted by all known versions of the text'.[23] This book thus treats *The Gold Rush* as a 'work' that encompasses many 'texts' while acknowledging the material forms in which these 'texts' were recorded. These are the forms in which the film has been seen over the years and it is important to take these differences into account instead of positing some imaginary ideal or 'original' version of the film.

Stillinger describes an enduring tendency to suppress textual variations in literature by positing a single version as authoritative, pointing out,

Scholars are of course aware of the existence of multiple versions of the works they investigate, whether the number is restricted to apparently authoritative manuscripts and printings or is expanded ... to include all versions wherever they occur… . But in general, the existence of multiple versions has been considered a challenge to the integrity of a work rather than an enrichment or a pleasing complexity. A principal object of traditional scholarship has been to get rid of the multiplicity as quickly as possible, either by designating a single existing version of a work as the best or most authoritative and then relegating partial information about the rest of the versions to one or another kind of limbo ... or else by combining parts

of several existing versions in such a way as to produce a new text altogether – creating, in the latter process, yet one more version to add to the historical array.[24]

The tendency to reduce a plurality of textual variations to a single authoritative version is especially strong for canonical works understood to be singularly great. It has perhaps been even stronger in film scholarship, where the desire to consider films as art must be reconciled with cinema's technological reproducibility: the 'work' is appreciated as a singular 'text' worthy of analysis, even if manifest in a multitude of identical copies.

 The two versions of *The Gold Rush* that have been most widely available during recent years are the sound version, *The Gold Rush* (1942), which was 'the last that the author ... had a hand in', and the silent version that David Gill and Kevin Brownlow reconstructed in 1992–3, 'combining parts of several existing versions in such a way as to produce a new text altogether' (in Stillinger's terms). The authoritativeness of each depends on a different idea of authorial intention: the former is the author's final version while the latter conforms to documents that presumably represent his original intent – namely two cutting continuities preserved in the Chaplin Archive.[25] The reconstructed version, which has been included as an additional option on authorised DVD publications of *The Gold Rush* since 2003, is a hybrid of material from different sources. Thus, it can only approximate what the film would have looked like in its 1925 forms, especially since some '75% of the scenes' in the reconstruction, according to Gill, were taken from a negative of the sound version.[26] It was released on video in two editions, one ninety-six minutes long, transferred at twenty-two frames per second, and the other eighty-eight minutes long, transferred at twenty-four frames per second.[27] The former is accompanied by music adapted from the score Carli D. Elinor composed for the 1925 Hollywood premiere and the latter is accompanied by music adapted from Chaplin's score for the sound version.[28]

This book offers a dynamic account of *The Gold Rush* that considers both authorised and unauthorised versions across the *longue durée* from the film's initial releases to its present-day iterations. Chaplin made extensive changes to *The Gold Rush* for its 1942 revival and thus it has two authorised production histories, both of which I discuss by drawing on the daily and weekly production reports kept by Chaplin's production company.[29] The reconstructed silent version that has come to stand in for versions of the film screened in 1925 has its own production history, which is detailed elsewhere.[30] Though I am interested in the shadow reproduction histories that lie behind dozens of unauthorised versions of *The Gold Rush* rented, sold and uploaded over the years, it is difficult to determine their respective provenances – much less to specify when and by whom these versions were copied, recopied, cropped and merged with different soundtracks.

This book embraces the multiplicity of *The Gold Rush*, resisting an urge to designate one or another version as authoritative. But, the existence of multiple versions presents a particular challenge for a 'textual analysis' of *The Gold Rush*. How does one analyse a cinematic 'text' in detail when the details have differed so frequently? Given such differences, I have generally avoided using frame enlargements to illustrate the book (except for comparative purposes). Instead, I have chosen to reproduce production stills, archival documents and relevant images from twentieth-century visual culture alongside my account of *The Gold Rush*. I have also opted for a non-linear analytical approach that is consistent both with the episodic way the film was made and the fragmentary way it is often remembered. In the end, I focus on several sequences that have defined the film for generations of viewers: the scene in which the cabin where the Lone Prospector (Chaplin) and Big Jim (Mack Swain) have taken refuge teeters precariously on the edge of a cliff; the sequence in which the Lone Prospector eats part of one of his boots, serving the other part of it to Big Jim; the scene in which a starving Big Jim hallucinates that 'the little fellow' is a chicken and

the dream sequence in which the love-struck Lone Prospector performs the famous dance of the rolls. These scenes, which may differ in duration, shot selection and/or soundtrack across various versions, are the ones most vividly recalled by viewers and most frequently remarked upon by reviewers and other commentators.

3 The Total Film-Maker

Chaplin is undoubtedly the singular *auteur* of *The Gold Rush*, the one person who exercised control over every phase of the film's production and its subsequent revival – a degree of individual control that was unrivalled in the era of the American studio system. He came up with the story and the incidents that make up the film; he directed the actors, among whom he had the leading part and he supervised the editing. Jerry Lewis aptly described Chaplin as 'the first great total film-maker' and

> the best example of a total film-maker. He was totally in, on, and all over his films. He created them in the fullest sense of the word: experimented to see how widely, how cleverly and skillfully he could work.[31]

The total film-maker, Lewis claimed, 'bears the sometimes expensive curse of never being really satisfied…. He is driven to this by being rather totally identified with his product'.[32] Chaplin appears to have totally identified with his films (just as audiences have totally identified many of Chaplin's films with him), putting much of his time and energy into their production and then protecting his ownership of them.

As a director, Chaplin was by all accounts a perfectionist who sought perfection through numerous retakes. Film comedian Max Linder, who spent time at Chaplin's studio during the early 1920s, emphasised Chaplin's great patience and his penchant for reshooting scenes:

> He goes over and over scenes until he is satisfied…. He keeps on starting again until he is content, and he is far harder to please than his most harshly critical spectator…. Chaplin works with a persevering obstinacy that must be unrivalled.[33]

According to one observer, Chaplin's 'continual cry, ceaseless as the waves of the sea' on the set of *The Gold Rush* was 'Just *once more* – we'll get it this time!'[34] Edward 'Eddie' Sutherland, one of several assistant directors of *The Gold Rush*, recalled the time-consuming process of making a film with Chaplin, 'Charlie has the patience of Job. Nothing is too much trouble. A real perfectionist'.[35]

Chaplin worked by a process of trial and error, shooting and reshooting various possibilities for many days before arriving at a satisfactory sequence. Chaplin alternated shooting and cutting, often editing together individual sequences long before filming was done. As scenes were completed, others were concocted. Sutherland explained,

Charlie shot pictures as we went along. We had a basic idea of the story, then we would do the incident every day. We'd shoot for three or four days, then lay off for two weeks and rewrite and perfect it and rarify it.[36]

Chaplin and Max Linder, © Roy Export Company Establishment

On days when they were not filming in 1924–5, the daily production reports often report Chaplin 'working on story' or 'working out new sequence'. Story sessions typically involved Chaplin and several of his collaborators, and often took place at his home.

According to daily production reports, the first day of filming *The Gold Rush* was 8 February 1924 and the last day of filming was 21 May 1925.[37] Over the span of these sixteen months, only 170 days of which were logged as working days in the production reports, some 231,501 feet – nearly forty-four miles – of negative were shot, which makes for a shooting ratio of greater than 27:1.[38] This immense quantity of footage included more than 5240 individual live-action shots. (Chaplin and his collaborators used the term 'scenes' for what are typically referred to as *shots*, and the term 'factions' for what are usually described as *scenes*, but I have adopted the more conventional terminology – except when quoting directly from documents in the Chaplin Archive – to avoid confusion.)[39] Sixteen years later, Chaplin was only slightly less profligate in his use of soundtrack negative for the revival of *The Gold Rush*. According to weekly production reports, during the nine months from 18 June 1941 to 4 February 1942, Chaplin worked on the sound version, some 135,445 feet of soundtrack were used (most recorded at the RCA studios in Hollywood) – a ratio of nearly 21:1.

Chaplin's insistence upon dozens of retakes of picture and sound while making and revising *The Gold Rush* indicates the exacting control he exercised over his films. In 1914, Chaplin began directing the films in which he starred and thus achieved greater individual control over the production process. He never relinquished this control and in fact consolidated his autonomy by building his own studio in 1917–18 and co-founding United Artists (with Mary Pickford, Douglas Fairbanks and D. W. Griffith) in 1919. But, once a film was finished and reproduced, Chaplin's control diminished radically. The fact that others altered and exhibited Chaplin's films without his authorisation was a continual source of frustration and frequently incited him to legal action.

The relative ease with which films could be copied and changed prevented Chaplin from ever achieving any real control over his films as physical objects. He nevertheless continued to try until the end of his life, but had greater success protecting legal rights to his films. *The Gold Rush* marks an important chapter in Chaplin's lifelong struggle to manage his filmed image – a struggle that has continued after his 1977 death through the actions of the Roy Export companies. The fate of *The Gold Rush* during the last twenty-five years of his life provided Chaplin with distressing confirmation of the perils of technological reproducibility, demonstrating what could be done with – and to – his work after he no longer had physical possession of the film and legal control over its reproduction. *The Gold Rush* had a life of its own, and its biography, so to speak, can only be written by examining its dual existence – on the one hand, as a set of material objects, each subject to physical manipulations, and on the other hand, as an immaterial piece of intellectual property regulated by historically fluctuating, internationally variable and often contested laws.

The founders of United Artists: (from left to right) Douglas Fairbanks, Mary Pickford, Chaplin and D. W. Griffith, © Roy Export Company Establishment

Chaplin's authorship of *The Gold Rush* is privileged throughout the book, but I also heed the crucial point film theorist Rudolf Arnheim made at the outset of his 1934 essay 'Who Is the Author of a Film?',

> The identity of the true author of a film concerns the legislator and judge, for it is their professional duty to determine who is responsible for the content of a film, who has the right to decide what a film shall be like and what shall be done with it, and also who shall profit, and to what extent, from the money it earns.[40]

This legal definition is an especially important complement to traditional ideas of authorship. It is a useful one to bring to bear on *The Gold Rush* since copyright law allowed the film to be re-authored while helping to determine how, when and in what forms it has been seen over the years. Just as importantly, United States laws and legal judgments set parameters for the way, and the extent to which, Chaplin could lawfully use existing sources in making and revising the film. From this perspective, Chaplin's lawyers Nathan Burkan, Loyd Wright and Charles Millikan emerge as meaningful collaborators, if not authors, within the film-making process more broadly conceived. Indeed, I would argue that they had as much to do with what *The Gold Rush* has looked like as some of the personnel directly involved in making and revising the film.

4 Origins and Originality

Chaplin took legal action on at least two continents to try to suppress the many unauthorised copies of *The Gold Rush* that circulated during his lifetime. While countless 'pirated' copies of *The Gold Rush* brought no direct remuneration to Chaplin, they did help make it one of the most widely available and best-known films of the silent era. As Robert Spoo points out in his study of copyright and modern literature, 'The typical and uncritical use of the term *piracy* – detached from the legal conditions that permitted and even encouraged it – gives a false aura of illegality to a practice that ... was a lawful form of cultural diffusion'.[41] Chaplin's 1956 re-release of the 1942 revival of *The Gold Rush* helped keep the

1956 lobby card

film before the cinema-going public at a time when silent films were largely considered obsolete, but it was the wider reach of piracy that helped guarantee its status as an enduring and popular classic.

The Gold Rush has come to epitomise what James Agee memorialised in 1949 as 'comedy's greatest era', but it was made as a genre film that relied partly on a viewer's recognition of the conventional characters, settings and situations of the Northern genre.[42] The film placed Chaplin's iconic tramp character in the generic world of the Northern for comic effect. As Iris Barry pointed out in 1925, 'in *The Gold Rush* Chaplin acts in ... the ordinary world of Alaskan film-drama with its fur-coated miners, flash houris, mining camps and snow'.[43] Chaplin consistently cited a stereoscopic photograph of the Chilkoot Pass and the story of the Donner Party as specific sources of inspiration for *The Gold Rush*, but the Chilkoot Pass and starving prospectors were also fairly generic Northern tropes that had long been parts of visual and narrative representations of the Klondike Gold Rush. In 1925, *Variety* even criticised the beginning of *The Gold Rush* as a cliché:

The opening shows an unending stream of prospectors negotiating the difficult Chilcoot Pass, and this is very beautiful in so far as scenery is concerned, but is tedious to an audience that has viewed similar scenes in the news weeklies and scenics many times before.[44]

Stories of prospectors starving during long, isolated winters in the Far North were likewise familiar from both fact and fiction.[45]

Northern conventions like these were especially important because *The Gold Rush* began as a genre parody. Writer Jim Tully, who dedicated his 1924 book *Beggars of Life: A Hobo Autobiography* to Chaplin, 'a mighty vagabond' and worked for Chaplin during the making of the film, said, 'Chaplin's original idea for "The Gold Rush" was ironical'.[46] After its release, *Variety* noted, 'Charlie Chaplin produced "The Gold Rush", according to

his own statement, as a satire upon gold seekers, Alaskan adventures and Far North writers, especially Rex Beach'.[47] Because the Northern film genre has faded since the 1920s, however, attention to the generic qualities of *The Gold Rush* has progressively diminished as both the Gold Rush and the Northern have receded further and further into historical memory.

In legal terms, generic material can be freely appropriated, but the specific characteristics of an individual work are proprietary. Chaplin continually negotiated this distinction through a series of lawsuits that took place at the same time he was making and revising *The Gold Rush*. His lawyers argued that both Chaplin's screen character and his films belonged to him and thus could not be legally copied. Simultaneously, another set of lawsuits obligated Chaplin's lawyers to demonstrate that his films were not in fact derived from the work of others. These legal struggles over issues of originality and the limits of duplication provide a crucial context for the making of *The Gold Rush* and its numerous subsequent reproductions.

Peter Decherney contends that copyright lawsuits effectively forced courts to delimit the boundaries of film genres: 'judges helped to define the Hollywood genre system, determining which elements belonged to all westerns, for example, and which were the sole property of a particular novelist, playwright, or filmmaker'.[48] The most contested examples, Decherney writes elsewhere, were comedies:

Chaplin and Jim Tully, © Roy Export Company Establishment, scan courtesy of Cineteca di Bologna

While we might dispute whether any artistic creation can be truly original, we would have to agree that comedy would certainly not exist without a referent on which to build, riff, or comment. Comedy is always about something else. It is a parody *of* another work or a joke *about* someone or something. Comedy, at its root, is about imitation, and, as a result, film comedy has consistently pushed the boundaries of copyright law.[49]

Along with genres of film and media, there are genres of performance that must mitigate claims to originality and accusations of imitation. What, for example, of the unmistakable resemblance between the famous Dance of the Oceana Roll Chaplin performs with a pair of forks and rolls in *The Gold Rush* and the fork-and-bread-roll shuffle Roscoe 'Fatty' Arbuckle, Chaplin's former Keystone co-star, performs in *The Rough House* (1918)? Was Chaplin imitating Arbuckle? Was Arbuckle imitating what he had seen Chaplin do earlier? Did others predate both Arbuckle and Chaplin in making rolls dance in this way? Was this stunt a genre of performance? Is there something about Chaplin's dance of the rolls in *The Gold Rush* that is singular – regardless of its primacy or its generic status? Chaplin was actively engaged in legally contesting questions like these (both as a plaintiff and as a defendant) in relation to the origins of his iconic tramp costume and the genesis of his films. What was at stake was nothing less than the possibility of originality within the collaboratively produced, technologically reproducible and often derivative art of cinema.

Chaplin was particularly sensitive to copyright issues not only because he worked in a mechanically reproducible medium, but also because his creative process depended heavily on appropriation. Composer David Raksin, who helped Chaplin score *Modern Times* (1936), aptly likened Chaplin's genius to the proverbial nesting behaviour of the magpie:

There is a specific kind of genius that traces its ancestry back to the magpie family, and Charlie was one of those. He had accumulated a veritable attic

full of memories and scraps of ideas, which he converted to his own purposes with great style and individuality. This can be perceived in the subject matter, as well as the execution, of his story lines and sequences.[50]

Or, as Chaplin's publicist Edward 'Eddie' Manson rather elliptically put it, 'Purloining ideas was the story line of procedure followed from sequence to sequence construction until a complete pattern would eventually formulate'.[51] The process of assemblage that was the foundation of Chaplin's approach to film-making also had legal ramifications. Joyce Milton's biography emphasises the range of Chaplin's creative appropriations while discussing a number of the resulting lawsuits.[52] Chaplin's successes in court were at least partly the result of his growing reputation as a legitimate artist, but presenting these arguments was the job of lawyers he employed in New York and Los Angeles.

The Rough House (1918)

5 The Work of the Artist and His Lawyers in an Age of Technological Reproducibility

Chaplin had commanded an increasingly remunerative series of contracts from Keystone, Essanay, Mutual and First National during the 1910s because these companies were able to profitably distribute so many copies of his films. Indeed, the record-breaking contract Chaplin signed with Mutual in 1916 ($10,000 per week plus a $150,000 signing bonus) was premised on the expectation that Mutual would make 'at least one hundred prints of each film'.[53] Cinema's technological reproducibility thus made Chaplin very wealthy, but it also meant that copies of his films could be made and altered by others without his permission.

Around the same time that he signed with Mutual, Chaplin became well aware of how little control he had over his filmed image. Chaplin's last film for Essanay, which he made in 1916, was a two-reel parody of *Carmen* (adaptations of which Cecil B. DeMille and Raoul Walsh had both filmed the year before). But, after Chaplin's work on the film was complete, Essanay increased the film to four reels without his consent. 'Chaplin's scenes were extended by salvaging his out-takes', and another director, Leo White, shot additional scenes with a new character

From the archives of Roy Export Company Establishment, scan courtesy of Cineteca di Bologna

(played by Ben Turpin) to stretch the film, titled *Charlie Chaplin's Burlesque on Carmen*, to feature length.[54] After Chaplin sued Essanay, but lost, Essanay was emboldened to cobble together the two-reel *Triple Trouble* (1918) from what remained of an unfinished Chaplin film, to which several sequences shot by White had been added.[55]

About this time, parts of another of Chaplin's Essanay shorts, the boxing film *The Champion* (1915), were bizarrely combined with footage from Herbert Brenon's undersea film *Daughter of the Gods* (1916) to produce a film titled *Charlie Chaplin in a Son of the Gods*, which was authorised neither by Essanay nor by Chaplin.[56] Essanay did not pursue the matter (the company was in the process of countersuing Chaplin), but Chaplin did, using Nathan Burkan, a New York lawyer who specialised in copyright law, to represent him. Ultimately, they were unable to suppress the film and succeeded only in preventing it from being billed as a Chaplin film. Because the eventual verdict 'cover[ed] only the advertising material and lobby posters' rather than the films, however, 'This limited decision actually encouraged other pirates', Joyce Milton notes.[57]

Despite the proliferation of unauthorised copies, Chaplin's films continued to be extremely profitable. *The Gold Rush* 'in a matter of a few years grossed over $4 million worldwide, earning the company $1 million and Chaplin a profit of $2 million'.[58] It was one of the most financially successful films of the silent period and coincided with the approbation Chaplin sought and received as a legitimate film artist at this time.[59] The aspirations of United Artists were clear in its name, but the success of *The Gold Rush* helped Chaplin achieve a level of artistic recognition that would never be accorded to Pickford, Fairbanks or even Griffith. As Charles Maland points out, 'Chaplin also managed by the mid-1920s to do something no other Hollywood star had: win the respect of American intellectuals'.[60] High regard for Chaplin's artistry was by no means confined to the United States. Indeed, around this time, critics around the world consistently lauded Chaplin as the consummate film artist. In 1921,

French critic and film-maker Louis Delluc (who did not live to see the release of *The Gold Rush*) published what David Robinson describes as 'the first serious monograph on a film artist in the history of cinema criticism' and it was devoted entirely to Chaplin.[61] Delluc thought Chaplin a 'genius', rhapsodically declaring, 'in this art of the *living* picture, this man is the first full-fledged creator. And so far he remains the only one'.[62] Delluc's *Charlot* was followed in 1923 by literary critic Viktor Shklovsky's book about Chaplin in Russian and in 1924 by Gerhard Ausleger's book *Charlie Chaplin* in German.[63] By the time he made *The Gold Rush*, Chaplin had become an international touchstone for understanding how film might constitute art.

Undoubtedly the most influential treatment of this topic came ten years later with Walter Benjamin's 'The Work of Art in the Age of Its Technological Reproducibility', an essay, it is worth noting, that exists in five distinct different versions. The second version, which dates from 1935–6 'represents the form in which Benjamin originally wished to see the work published', according to the editors of the most recent English-language edition of Benjamin's writings.[64] For Benjamin, Chaplin was a revealing example of the differences between technologically reproducible and traditional art. He mentioned *The Gold Rush* in passing as an example of film art, but focused more on what Chaplin's working methods indicated about the character of the film medium itself:

> Film is the first art form whose artistic character is entirely determined by its reproducibility… . The finished film is the exact antithesis of a work created at a single stroke. It is assembled from a very large number of images and image sequences that offer an array of choices to the editor; these images, moreover, can be improved in any desired way in the process leading from the initial take to the final cut. To produce *A Woman of Paris*, which is 3,000 meters long, Chaplin shot 125,000 meters of film. *The film is therefore the artwork most capable of improvement.*[65]

For Benjamin, technological reproducibility fundamentally transformed the character of art, eroding the very concept of authenticity and dispelling what he describes as the 'aura' of both the original art object and the live stage performer. But, it is worth stressing that Benjamin based his frequently cited argument not only on the medium's technological reproducibility (the fact that many identical copies of a film can readily be made), but also on film's capacity for continual alterations – that is, being '*capable of improvement*'. Benjamin's numbers relative to the shooting ratio of *A Woman of Paris* (1923) appear wildly exaggerated, but Chaplin's reputation for generating voluminous quantities of footage in the course of a production made him an exemplary representative of an approach to film-making that maximised the perfectibility of films as works of art.[66]

By the time Benjamin wrote 'The Work of Art in the Age of Its Technological Reproducibility', Chaplin had already been effectively anointed as the quintessential film artist. In *Film als Kunst*, a book Benjamin cites more than once, Rudolf Arnheim asserted 'that Charlie Chaplin … may be discussed just as seriously as Titian'.[67] Such superlative critical assessments of Chaplin's artistry were numerous during the late 1920s and early 1930s and left an indelible mark on the cinematic canon.

While *The Gold Rush* marked Chaplin's elevation to the loftiest heights of film art, it also coincided with several precedent-setting legal disputes that adjudicated what constituted originality and

individual creation in a commercial mass medium. Chaplin's associates remembered him as often being parsimonious when it came to his personal wardrobe and to compensating his employees, but he incurred substantial legal expenses in order to pursue both imitators and unauthorised copies of his films. A few months before completing *The Gold Rush*, Chaplin was involved in a lawsuit that took him away from the studio to testify in Los Angeles court as part of a case against Charles Amador, a Mexican film actor who used the name 'Charlie Aplin' and wore a costume much like Chaplin's tramp garb.[68] Chaplin's complaint contended that Amador imitated Chaplin's 'ways and mannerisms, dress and facial expressions ... for the purpose of deceiving theatregoers'.[69] Amador eventually agreed to stop using the name 'Charlie Aplin', but continued making films, so Chaplin pressed on with the lawsuit.[70] Los Angeles lawyers Loyd Wright and Charles Millikan represented Chaplin when the case came to trial in 1925.

Chaplin claimed Amador was 'impersonating him', but during the trial, Amador's attorneys (Ben Goldman, Jacob Lieberman and Isidore Morris) answered this charge by demonstrating that every one of the visual elements that made up Chaplin's purportedly unique film character – toothbrush mustache, undersized coat, oversized pants, floppy shoes and flexible cane – had been previously employed by other stage comedians.[71] Costume – and Chaplin's trousers in particular – ended up being a crucial factor in the trial.[72] Amador's lawyers called Chaplin as a witness for the defence on 19 February 1925 (less than a week after filming the Oceana Roll) to question him about the origins of his costume, attempting to show that it was hardly unique given the long tradition of tramp comedians. That same day, the defence also tried to screen film performances by Chaplin, Amador and Billy West (the Chaplin imitator whom Amador testified he was employed to imitate), but were thwarted when one reel 'caught fire and flaming bits of celluloid were scattered among the spectators in a temporary courtroom'.[73] In his testimony, Chaplin acknowledged the inspirations for several of the features of

his distinctive character, testifying, 'I got ... my walk from an old London cab driver... . Fred Kitchen, an old fellow trouper in vaudeville, gave me the flat feet', but insisted that 'he was the first to combine different parts of the makeup'.[74] Judge John L. Hudner concurred that it was 'the ensemble ... the complete Chaplin make-up' which was at issue, not any of its individual features.[75]

Chaplin and his counsel thus successfully argued that Chaplin's 'originality' was rooted in selective appropriation and reconfiguration – a process that was totally distinct from the mere act of copying. Jennifer Bean explains,

> The peculiar twist through which Chaplin mounted a position that would confer 'original' rights for the tramp costume and character overtly avoided traditional claims for authenticity, those predicated on an artist's capacity for inward reflection. He opted instead to intermingle a studied process of 'copying' with more spontaneous bouts of whimsy... . The upshot of the trial, however, emerged from Chaplin's capacity to argue for his role as something less than an artist, and more like an assembler of the tramp's disparate parts.[76]

The outcome of the trial was somewhat ambiguous because it focused on how Amador and his producers had attempted to deceive the public through their use of the name 'Charlie Aplin' and a misleading advertising campaign that deliberately confused the identity of the comic performer in films like *The Race Track* (1920). The judgment failed to specify what constituted 'imitation', leaving that question open to future judgments on specific cases.[77] Thus, both sides in Chaplin vs. Amador claimed victory.[78] Competing newspaper headlines, some reporting Chaplin had won and others reporting he had lost, evidence the ambivalence of the decision.[79] Chaplin was dissatisfied with the outcome and chose to appeal it, eventually winning a 1928 judgment whereby 'Charles Amador or "Charles Aplin", and the Western Features Productions, Inc... . were permanently enjoined from the manufacture and sale of "fraudulent" moving pictures'.[80]

Amador's films were deemed 'fraudulent' because his screen persona (and in particular his costume) looked so much like Chaplin's that viewers could easily confuse them. This judgment bolstered Chaplin's rights to his celebrated tramp character and cemented its exclusive connection to his surname, but his films were simultaneously subject to similar charges of plagiarism. In Loeb vs Chaplin, Leo Loeb's lawyer Mortimer Hays argued that Chaplin's film *Shoulder Arms* (1918) was plagiarised from Loeb's scenario 'The Rookie', which he had submitted to Chaplin's production company not long before work on the film began.[81] On 29 May 1924, according to daily production reports, nothing was done on *The Gold Rush* because Chaplin, older half-brother Sydney 'Syd' Chaplin (who worked with and for Chaplin while continuing his own acting career) and several others employed at the studio were giving depositions in connection with Loeb's $50,000 lawsuit.[82] When the suit was finally tried in May 1927, Loeb's attorney mounted a strong enough case to split the jury ten to two against Chaplin (who was being represented by Nathan Burkan).[83] Since the jury could not agree on a verdict, the case was retried a few months later and eventually decided in Chaplin's favour.[84]

Chaplin prevailed in a number of such cases, but for decades was dogged by accusations that what he had derived from others exceeded legal limits. Jean Sarment suggested that Chaplin had borrowed from his play *Les plus beaux yeux du monde* in *City Lights* (1931) and requested arbitration, although the matter was never litigated.[85] French film producer Films Sonores Tobis sued Chaplin for allegedly having plagiarised a scene of *Modern Times* from René Clair's *À nous la liberté* (1931), apparently getting evidence from a private detective that 'Chaplin had obtained an unauthorized duplicate print of the Clair film… [and] had run the assembly-line sequence from *À nous la liberté* at least a dozen times'. Chaplin's lawyers, however, 'argued that an assembly-line speed-up was a generic situation and no one could claim to own the idea'.[86] A few years later, when he was at work reviving *The Gold Rush*, his

longtime associate Konrad Bercovici sued him for $5 million, claiming that the idea for *The Great Dictator* (1940) was Bercovici's.[87]

During the early 1940s, Chaplin continued to be on the lookout for unauthorised copies of his films. When Kathleen Pryor, a stenographer who worked for Chaplin's production company, saw *The Gold Rush* advertised as part of a 'Silent Movie Revivals' night in Los Angeles, Chaplin immediately referred the matter to his New York lawyers, Arthur Schwartz and Louis Frolich. The law office of Schwartz & Frolich managed to trace the print to Cine Film Products in Patterson, New Jersey, which was circulating a 'cut version' of *The Gold Rush* in 16mm under the title *Arctic Adventures*.[88] Alfred 'Alf' Reeves, Chaplin's studio manager, wrote to Schwartz, 'I have talked to Charlie on this and he is of the opinion we should protect our rights to the limit'.[89] This they did, winning judgments against Cine Film Products and another New Jersey camera shop, Gruber's Camera Exchange, for renting 16mm versions of *The Gold Rush* (a third New Jersey defendant, Peerless Camera and Film Service,

Konrad Bercovici and Chaplin during the filming of *The Gold Rush* © Roy Export Company Establishment, scan courtesy of Cineteca di Bologna

went out of business before the case was settled). The films were recovered, along with rental records, but the financial settlements received in the three cases ($375) were less than Chaplin's legal costs.[90] Shortly after the cases were resolved, Reeves wrote to Loyd Wright with some frustration, 'It seems that the people who put these version[s] out pass the buck and are financially irresponsible, and we haven't gotten much satisfaction out of them', adding, 'Charlie is generally quite anxious these piracies of his older pictures be not allowed to go undisturbed'.[91]

As he came to the end of revising *The Gold Rush* late in 1941, Chaplin and his associates continued to be sensitive to issues of originality and the legal repercussions that could result from similarities between his films and those of others. Weekly production reports note that on 26 December 1941, Reeves enquired whether the comedy *You're in the Army Now* (1941), which includes a scene that shows a house balanced on the edge of a cliff, was a 'possible infringement of "Gold Rush" "rolling cabin scene"'. On 30 December 1941, Chaplin screened *The Ramparts We Watch* (1940) 'to see if any similarity between music in that picture and "The Gold Rush"'. However, neither of these two possible resemblances was pursued.

6 'The Lucky Strike'

The importance of copyright for Chaplin's creative process is confirmed by the very first entry in the production reports his production company kept for *The Gold Rush*: it records the copyright registration of 'The Lucky Strike' with the Library of Congress on 3 December 1923. Copyrighting 'The Lucky Strike: A Play in Two Acts' as a 'dramatic composition' gave Chaplin some measure of ownership over several initial ideas for the film as well as the title. The 1909 United States Copyright Act extended copyright to certain unpublished works, including plays, permitting playwrights and theatre producers to copyright play scripts and thus limit unauthorised performances of their work by submitting a copy of the script to the copyright office.[92] This extension of copyright did not include unproduced motion pictures. Indeed, the copyright guidelines circulated by the Library of Congress end with the following 'Special Notice':

Registration is not permissible under the designation 'Dramatic Composition' for motion picture scenarios or synopses... . The motion picture scenario is protected when it has been used as a basis for a motion picture and the latter is duly registered.[93]

This paragraph is marked with an 'X' on the copy that survives in the Chaplin Archive among files Chaplin's production company kept for *The Gold Rush*.[94] Film producers nevertheless sometimes sought protection for unproduced or unfinished films by copyrighting them as 'unpublished dramatic compositions'. More than a year after copyrighting 'The Lucky Strike', Chaplin sought additional copyright protection for his forthcoming film as the end of the shoot neared, registering a script titled 'The Gold Rush' for copyright on 10 March

THE LUCKY STRIKE.

A play in two acts, and written by Charles Chaplin.

CAST

Charlie..........
Mary.............
Bad Bill.........
The Rat..........

Locale. Alaska. First Scene The Great Outdoors.
 Act 1.

Charlie. (soliliquizing) "Oh, for my nice warm home." (looking around)

"But here I am safe." At this moment a bear starts to cross the stage Charlie sees him and exits followed by the bear.

Scene 2

Interior of a big dance hall and bar in Alaska'
Bartenders, dancing girls, miners etc., discovered on stage.

Charlie enters. rushes to bar.

Charlie. "Two drinks please."

Bartender "Two?"

Charlie. "Yes two for me, and one for you, there's luck in odd numbers."

Bartender "Your health."

Charlie "Pretty good now, and yours?"

Bartender "Stranger here?"

Charlie "Yes, any excitement here?"

Bartender "Sometimes, there is supposed to be a big prizefight here tonight, but they can't find a man to step in the ring with Bad Bill."

Charlie "Who is Bad Bill ?"

Bartender "See that guy over there?" (pointing)

Bad Bill, a big rough tough looking indivual is just at this this moment bending a horse shoe straight, and as Charlie looks at him he speaks

Bad Bill "I can lick any guy in the world" (drinks his drink.

Mary "Isn't he wonderful?"

'The Lucky Strike', 1923, Library of Congress, © Roy Export Company Establishment

1925 as an 'unpublished dramatic composition in three scenes'. Although it omits the climactic teetering cabin, it contains many of the film's other scenes, but is written like a play, complete with dialogue and phrases like 'curtains rise'.[95]

The eight hastily typewritten pages of 'The Lucky Strike' initially submitted for copyright in 1923 constitute a fairly inchoate and episodic dramatic sketch. 'The Lucky Strike' documents what David Robinson describes as 'Chaplin's method of starting the construction of a film by assembling a disparate stack of potential gags, scenes or hazy notions'.[96] Most of the action takes place at 'a big dance hall and bar in Alaska' where Charlie surprises 'Bad Bill, a big rough tough looking indiv[id]ual' by knocking him out in a prizefight, winning a ten-thousand dollar purse and, with it, the chance to marry Mary, who will wed the winner because she needs the money to send her sick younger sister home to a warmer climate: 'The action of this fight is purely comedy, and after a series of gags that will have to be ad libbed, Charlie is victorious and knocks out Bad Bill'.[97]

A big fistfight had been a generic feature of Northerns set during the Gold Rush since Rex Beach's novel *The Spoilers*, which was published in 1905 and adapted to film in 1914 and 1923. Goldwyn's 1923 version was billed as an adaptation of 'Rex Beach's two-fisted novel of Klondike days'.[98] In 1923, former boxer Jim Tully visited the set of *The Spoilers* with the boxer Charles 'Kid' McCoy while the fight was being shot and then published a blow-by-blow

Film Daily, 29 July 1923

account of the filmed fisticuffs.[99] A year later, both Tully and McCoy spent time at Chaplin's studio as Chaplin began work on *The Gold Rush*.

A production report dated 26 January 1924 notes, 'Mack Swain engaged as "heavy"', suggesting that Swain was initially cast as an antagonist. Swain's character may in fact have been conceived along the lines of Bad Bill. Several photographs dated March 1924 show Chaplin and Swain in boxing gloves posing as combatants in a boxing ring as McCoy looks on. An article published a few months later about the making of the film mentions Swain and Charles 'Chuck' Riesner among the principal members of the cast, noting that Riesner (yet another former boxer) played 'the boxer in *The Kid*'.[100]

Several production stills that appear to have been taken early in 1925 show the Lone Prospector in front of a boxing poster and a

'Kid' McCoy, Chaplin and Mack Swain stage a boxing match, March 1924, © Roy Export Company Establishment, scan courtesy of Cineteca di Bologna

Chaplin and Riesner in *The Kid* (1921), © Roy Export S.A.S.; Chaplin in a scene that was not used in the film, 1925, © Roy Export Company Establishment, scan courtesy of Cineteca di Bologna

chalkboard that reads, 'BOXERS WANTED FOR BIG BENEFIT WILL PAY WELL ENQUIRE WITHIN'. These photographs suggest that Chaplin was still trying to incorporate the boxing component of 'The Lucky Strike' into *The Gold Rush* relatively late in the production process. As David Robinson notes, 'Chaplin loved boxing at this time – going to prize-fights with members of his staff was his favorite leisure occupation'.[101] No boxing match appears in *The Gold Rush*, although Chaplin may have shot some boxing footage for the film in 1924–5. He returned to this idea in shooting the virtuoso boxing sequence for *City Lights* (1931), and, as anticipated in 'The Lucky Strike', 'The action of this fight is purely comedy'.

'The Lucky Strike', Jeffrey Vance points out, 'bears very little resemblance to the narrative of the finished film'.[102] But, it provides a rough sketch of character relationships that Chaplin used in the part of the film set in the unnamed city 'in the Far North, built

City Lights (1931)

overnight during the great gold rush' (as an intertitle reads).[103] The antagonism between the newcomer Charlie and Bad Bill over who will marry Mary is not unlike the rivalry between the Lone Prospector and Jack Cameron (Malcolm Waite) over Georgia (Georgia Hale) in the Monte Carlo Dance Hall – especially in the sound version, where Georgia's affection for 'the little fellow' is visibly greater. The phrase 'Lucky Strike' was also used in silent versions of *The Gold Rush* as an intertitle – albeit without the double meaning it carries in 'The Lucky Strike' – to mark Big Jim finding a gold nugget outside his tent.

Chaplin made use of several other ideas from 'The Lucky Strike', but modified them considerably. In 'The Lucky Strike', Charlie's punch drops Bad Bill, but in *The Gold Rush*, a clock falls unexpectedly on Jack's head just as the Lone Prospector throws an errant blow with his hat pulled down over his eyes. This leads the Lone Prospector to believe he has knocked Jack out. He struts triumphantly out of the dance hall, unaware that he had nothing to do with rendering Jack unconscious. A change was also made to Act 1, Scene 1 of 'The Lucky Strike', which begins as follows:

Charlie. (soliliquizing [sic]) 'Oh, for my nice warm home[.]' (looking around) 'But here I am safe.' At this moment a bear starts to cross the stage[.] Charlie sees him and exits followed by the bear.[104]

In *The Gold Rush*, the comedy is visual rather than verbal and, like the knockout, the Lone Prospector is unaware of what is going on around him. Rounding a bend on a precipitous mountain path, he does not see a bear emerge from a cave and follow right behind him – the bear ambles into a cave as the Lone Prospector walks safely along, not knowing how close he came. This became one of the first gags in the film.

Some uncertainty about the title of the film persisted as the premiere approached: on 23 April 1925, the *Los Angeles Times* noted, 'Charlie Chaplin is now in the throes of finishing his last reel

of "The Gold Rush" or "The Lucky Strike" or whatever he decides to name his latest picture'. According to Chaplin, who was quoted in the article, 'Some people think if we name it "Lucky Strike" the fans might get it mixed with the cigarettes. So we don't know. Anyhow, I'm a bit superstitious about using the word "lucky"'.[105] Another article in the trade press prior to its release suggested the film might be titled 'The Frozen North', a possibility that must have seemed unlikely since that title had been used just three years earlier for a two-reel Northern comedy starring Buster Keaton.[106]

7 A Northern Comedy

When *The Gold Rush* was announced as the title of Chaplin's forthcoming film, it was initially mistakenly reported to be 'a story of the "Forty-Niners"'.[107] A subsequent notice made clear, however, that the new film would in fact be set during 'Alaska gold mining days'.[108] Chaplin's decision to have *The Gold Rush* take place during the 1897–8 Klondike Gold Rush placed it squarely within the well-established Northern genre, which spanned theatre, literature and film, encompassing stories about trappers, adventurers, lumberjacks, miners, Mounties, Eskimos and others – even animals – in the Far North. Like many Westerns, Northerns were typically situated on the frontier where European and American settlement had only begun to encroach on daunting wilderness. Northerns went by a variety of generic labels and included non-fiction as well as fiction. Representations of the Gold Rush made up a significant subgenre of the Northern during the early twentieth century.

One of the earliest Northerns to appear in the wake of the Gold Rush was *The Klondyke Nugget*, a play that was performed in England from 1898 to 1903, the same years that Chaplin, still a child, was touring English theatres first as a clog dancer with The Eight Lancashire Lads and later as a comic supporting actor.[109] *The Klondyke Nugget* was written by S. F. Cody, who was born Samuel Franklin Cowdery but began using the name Cody after he started performing in Wild West shows – an Aplin-like attempt to trade on the name recognition of his far more famous contemporary William F. Cody, 'Buffalo Bill'. A popular sensational melodrama, *The Klondyke Nugget* transposed elements of the Western to the Klondike region (then the western frontier of British dominion in Canada bordering the District of Alaska administered by the United States). Cody began writing the play as a Western that would allow

him to showcase his trick shooting and horsemanship, but turned it into a Northern in order to capitalise on the topicality of the Gold Rush. Thus, the play contains a number of Western elements, including sharpshooting (performed by Cody himself, with snowballs), a horse's plunge from a broken bridge and a fatal shooting in a saloon. Like many Westerns, it has 'good' and 'bad' Indian characters, although the latter far outnumber the former. *The Klondyke Nugget* also incorporates several references to locations linked to the Gold Rush – namely the settings of 'the Chilcoot Pass' and 'the Elderado Saloon'. Other elements of *The Klondyke Nugget* that subsequently became staples of Northern fictions set during the Gold Rush are the 'snow scene', the gold 'mining scene', 'a grizzly bear, who tried to have dinner with me' (as one of the characters in the play says) and the eponymous gold nugget. *The Klondyke Nugget* climaxes with the protagonist, George Exelby (Cody) rescuing his lover Rosie (or Rosy) Lee (Lela Cody [*née* Lela Davis]) from a cabin immediately before it gets 'blown to smithereens' – a spectacular effect that was accomplished on the

David Mayer collection

stage by means of a 'mechanical cabin'.[110] Cody's biographer writes, 'It was an immense success, and continued to tour Great Britain more or less continuously for the next four years'.[111]

Unlike *The Klondyke Nugget*, which could only simulate a Northern setting through scenography and stage effects, contemporaneous Gold Rush films shot on location provided audiences with exotic topical views. The Gold Rush was almost immediately the subject for non-fiction films shot on location. In 1899, Thomas Crahan and Robert Bonine travelled north to film in Alaska and the Yukon for their newly formed Klondike Exposition Company.[112] Edison sold the films made on this expedition as part of a 'Special Klondike Series'.[113] In 1903, the travel lecturer Burton Holmes toured Alaska, where cameraman Oscar Depue 'filmed the gold miners and their sluicing and hydraulic operations'.[114] Holmes projected these films, with magic lantern slides, to illustrate his travelogues. Charles Urban released the series in England by special arrangement with Holmes under the title *The Klondyke of To-day* (1907).

The Klondyke of To-day, subtitled 'Life on the Gold Claims of Alaska, and among the Eskimo near Behring Straits', represented the Gold Rush through a metonymic set of images that were already, in a sense, generic. The film showed the spectacular scenery of the North, scenes of Eskimo life, methods of mining and the town of Dawson City, while highlighting 'Dog teams' and '"Mush" Dogs' at work and play – one was shown tussling with a bear. Such subjects had already been used to represent the Gold Rush and would appear in numerous subsequent Northerns. Several of the generic Northern elements of *The Klondyke of To-day*, including 'A modern mining town ... with its heterogeneous population', sled dogs and a bear, are present in *The Gold Rush*.[115] Chaplin may not have seen either *The Klondyke Nugget* or *The Klondyke of To-day* while he lived in England, but taken together, these two works outline some of the most recognisable conventions of the Gold Rush Northern as it took shape in transatlantic popular culture around the turn of the

century. These generic conventions were adopted by novelists and film-makers.

Jack London was the most prominent of the writers who treated the Klondike of the Gold Rush as a frigid crucible where Darwin's axiom of the 'survival of the fittest' was borne out. London went north during the summer of 1897. One of his companions on the journey was 'Big Jim' Goodman, with whom he staked several claims and shared a cabin for the winter.[116] After surviving a near-fatal bout of scurvy, London returned to Oakland the next summer without any gold, but he would draw on his experiences during the Gold Rush for a number of subsequent short stories, essays and novels.[117] 'In a Far Country', first published in 1899, tells of two gold-seekers who find themselves together in a cabin for the winter – as their food supply dwindles during long months of isolation, they are driven to hallucinations and ultimately to killing each other.[118] Although neither perishes in the end, these are the circumstances for Big Jim and the Lone Prospector while confined to a cabin without food. Similarly, in London's 1902 non-fiction piece 'The Gold Hunters of the North', he describes how cabin-mates decided who would brave the winter elements to bring back necessities: 'Each winter, eight months long, the heroes of the frost faced starvation. It became the custom ... for partners to cut the cards to determine which should hit the hazardous trail'.[119] This custom appears in *The Gold Rush* with a comic twist when the Lone Prospector cuts a three, throws down the cards in disgust and prepares to go outside in search of food, only to see Black Larsen (Tom Murray) – Black Larson in the sound version – cut an even lower card, a two.

Another Gold Rush Northern convention found in both London's writings and *The Gold Rush* is the general distinction between newcomer and experienced prospector that contrasts the Lone Prospector with Big Jim – a contrast underscored by the respective costumes and physiques of Chaplin and Mack Swain. London explained the difference between the novice 'cheechako' and the experienced 'sourdough' in his 1906 novel *White Fang*,

These men had been long in the country. They called themselves Sourdoughs, and took great pride in so classifying themselves. For other men, new in the land, they felt nothing but disdain. The men who came ashore from the steamers were newcomers. They were known as *chechaquos*, and they always wilted at the application of the name. They made their bread with baking-powder. This was the invidious distinction between them and the Sour-doughs, who made their bread from sour-dough because they had no baking powder.[120]

Use of the terms 'sourdough' and 'cheechako' (an Anglicisation of the Chinook word for newcomer – spelt and capitalised in various ways) may have been initially confined to the vernacular of Alaska and the northeast, but these words became much more familiar at the turn of the century through writings about the Gold Rush.[121] They continued to be recognised referents into the 1920s. An exhibitor in Fall River, Massachusetts publicised *The Law of the Yukon* (1920) by arranging a 'sour dough reunion ... in which all those men who took part in the Alaskan gold rush in 1898, were invited to the theater'.[122] In *The Gold Rush*, a sign depicted in an insert shot marks the spot where 'Jim Sourdough ... got lost in the snow Friday 1898'.

 The title of the independently produced film *The Chechahcos* (1924) co-opted the regionalism that was more or less the opposite of 'sourdough'.[123] Advertisements usefully provided a pronunciation guide, '(pronounced chee-chaw-koze)' below the film's title. Although these terms had mostly fallen out of usage by the time *The Gold Rush* was revived (Chaplin does not use the word 'sourdough' – much less 'cheechako' – in his narration), at least one review of the 1942 version harked back to the former word, alliteratively captioning a picture of the Lone Prospector, 'Charlie Chaplin, as the chilblained cheechako of *The Gold Rush*'.[124]

 The Chechahcos was filmed entirely in Alaska and was advertised as an authentic representation of the Gold Rush. One advertisement rhetorically asked exhibitors,

> **puzzled**
> Are you wondering why we persist in using an unusual title like chechahco?
> Couldn't we have found something simpler? Certainly we could. We might have named the picture "The Gold Rush" or "The Birth of Alaska," or what-not, but these would have classified it as an ordinary movie. And that's just what this picture isn't.
>
> **chechahcos**
> is as different in quality and appeal as its intriguing title is different from ordinary titles.
>
> **Associated Exhibitors**

Are you wondering why we persist in using an unusual title like chechahco? Couldn't we have found something simpler? Certainly we could. We might have named the picture 'The Gold Rush' or 'The Birth of Alaska,' or what-not, but these would have classified it as an ordinary movie. And that's just what this picture isn't.[125]

The film's producers thus sought to distinguish *The Chechahcos* from any of a number of 'ordinary movie' Northerns. One year later in 1925, Chaplin used just such a predictable title for his new film. As a parody, however, *The Gold Rush* is far more invested in referencing and in poking fun at the conventions of the Northern than it is in accurately depicting either history or location.

The Chechahcos details the long journey to Alaska during the Gold Rush and includes a sequence where the travellers cross over the infamous Chilkoot Pass. An advertisement for the film shows a procession of people snaking over the snow-covered Chilkoot Pass en route to Alaska, one of countless variations of an image used to represent the Gold Rush from its earliest days, different versions of which proliferated in turn-of-the-century popular culture. In 1898 alone, images of the Chilkoot Pass could be seen in the Biograph film *Pack Train on Chilkoot Pass*, in the scenery for much of Act 2 of *The Klondyke Nugget*, on the cover of the first issue of the dime-novel adventure series *The Klondike Kit Library* and even in advertisements for packaged foods.[126]

Film Daily, 6 April 1924

A number of other Northern Gold Rush films were produced in the years before *The Gold Rush* was released, including *The Grub-Stake* (1923), *Gold Madness* (1923), *The Lure of the Yukon* (1924) and *The Shooting of Dan McGrew* (1924), among others. Film reviewers pointed out that Northerns set during the Gold Rush tended to rely on certain conventions. About *The Mints of Hell* (1919), a 'Klondike mining melodrama', one review noted, 'Instead of locations being found to suit the story, this seems to be ... a story ... [that] was devised to fit the locations'.[127] A few years later, *Belle of Alaska* (1922) was advertised as the 'biggest Klondike picture since *The Barrier*', though at least one review conceded that it was 'built with familiar material'.[128] Several key elements of this 'familiar material' were mentioned in a review of the contemporaneous serial *Perils of the Yukon* (1922) in *Film Daily*, 'The story calls for snow scenes, dog sleds and the romantic life of Alaska in the gold days. A gold claim and scheming bad men help out the plot'.[129]

Northerns were defined by precipitation as well as by geographical setting. As Mark Sandberg points out, films set in the North were sometimes termed 'snow pictures'. During the silent period, the preferred location for Hollywood film-makers to shoot snow scenes was the Truckee area in the northern Sierra Nevada mountain range. By the early 1920s, Northern 'snow pictures' were established well enough as a genre to have been parodied in such

films as *The Frozen North* and *Yukon Jake* (1924), with Ben Turpin.[130] *The Gold Rush* was initially classed among these parodies.

A production report dated 5 January 1924 indicates that Chaplin was preparing to go on location for *The Gold Rush* from the beginning. Publicist Eddie Manson recalled,

> As per Chaplin formula of movie making, it was still just an idea; a title, something, anything, to hang a story on, a story, that as of yet had no outline. About the only thing we knew for sure, it was going to be about the frozen north and for that background of a plot, we had to have snow.[131]

According to daily production reports, the next few weeks of January were spent 'selecting and making costumes for Northern story' and working on 'snow and blizzard effects' in the studio. From 20 to 25 February 1924, Chaplin scouted possible locations around Truckee with cinematographer Rollie Totheroh, associate director Chuck Riesner and technical director Charles 'Danny' Hall. Location shooting was done in the snow around Summit, California, between Truckee and Sacramento, from 19 April to 29 April 1924, consuming approximately 35,000 feet of film. According to Jim Tully, who worked on story ideas for *The Gold Rush* and went on location to Summit, 'Chaplin worried greatly for fear the snow would be melted' so late in the season.[132] On 23 April, after two feet of snow had fallen, Eddie Sutherland was called upon to direct because Chaplin was sick in bed but did not want to miss the chance to film in the snow, which was continuing to fall. Unlike other days the company was on location, 'Everything covered with snow and snowed nearly all day'. In the end, much of the location footage shot in the snow was not used. Instead, precipitation was simulated in the studio with a reported '100 barrels of flour', along with 'four carloads of confetti ... employed in producing blizzard and snow scenes'.[133]

An 11 June 1924 letter from Arthur Kelly of United Artists to Syd Chaplin indicates that *The Gold Rush* was very much a 'snow

THE GOLD RUSH | 55

Chaplin on location suffering the effects of illness, © Roy Export S.A.S., scan courtesy of Cineteca di Bologna; John Brown and Lita Grey on location, © Roy Export Company Establishment, scan courtesy of Cineteca di Bologna

picture'. In the letter, Kelly pointed out that there were already a number of 'Alaskan pictures on the market', adding, 'I myself in the last month have seen at least five all with snow scenes', but conceded, 'but of course none of them have been comedies'.[134] Along with snow scenes, animals were a fairly ubiquitous part of Northerns. In *Where the North Begins* (1923), the dog, played by Rin-Tin-Tin, received top billing over his human co-stars.[135] London helped mythologise sled dogs in *White Fang* (adapted into a film in 1925) and *The Call of the Wild* (adapted into a film in 1923). Recognising the importance of dogs for a Northern story, Chaplin brought 'Mr. Niemeyer and 10 husky dogs' to the studio for filming beginning on 29 February 1924 – several days before signing female lead Lita Grey. Also preceding Grey in the cast was John Brown, a brown bear that started in the studio on 27 February with handler Bud White. John Brown went on location with the company and appears in both of the film's bear scenes.[136]

8 Historical Referents

In his testimony in the *Shoulder Arms* lawsuit, Chaplin said that he did not work from scenarios, 'My pictures are conceived as I go along. The creative mind doesn't work from detailed directions'.[137] Chaplin made *The Gold Rush* without a script, but he worked partly from historical sources. Lita Grey recalled that he 'read everything available on the search for gold in Alaska in 1898... . He was determined to capture the authentic quality of 1898 Alaska'.[138] In his autobiography, Chaplin wrote that a stereoscopic photograph of the Chilkoot Pass and the story of the Donner Party had inspired the film.[139]

At the time of the Gold Rush, the most direct route to the Klondike was through the Chilkoot Pass, a rocky incline too steep for pack animals to traverse. Many made the ascent with equipment and provisions on their backs, and the image of people plodding through the snow in a single file line came to epitomise the struggles experienced by those who went north seeking wealth. As Richard J. Friesen writes,

The single picture of the long, thin line of men bent under their heavy packs, straining upward on the steep, snow-covered slope was immediately recognized. The long, thin line stretched upward, disappearing into a barely discernible notch in the distant ridge. The stark contrast of the struggling humanity on the glittering white snow symbolizes at once the elation of hope and the unbearable futility of the Rush of '98.[140]

This image quickly became closely associated with the Gold Rush. A number of different versions were published as stereograph cards.[141] Viewed in a stereopticon, the mountain in the background and the long line of people stretching into the distance provide the kind of

depth effect that made the stereoscope such a popular turn-of-the-century amusement.

Chaplin went to great lengths to replicate both the image and the 'caption printed on the back describing the trials and hardships endured in surmounting it' while shooting on location in Summit.[142] Colourful accounts of location shooting for *The Gold Rush* in northern California by Lita Grey, Eddie Manson, Eddie Sutherland and Jim Tully convey some of the difficulties experienced filming in the Sierra Nevada Mountains.[143] These difficulties included cutting a path in the snow, constructing buildings (some of which never appear

Two stereoscope cards showing photographs of the crossing of the Chilkoot Pass: each is slightly different but both bear the same title and catalogue number. Bancroft Library

in the film), along with transporting, lodging and feeding several hundred hobos brought by special train from Sacramento as extras – all for a few shots that make up the Chilkoot Pass sequence of the film.[144] Interviewed on location, Chaplin said, 'I think it will have historic value, for one thing. Our Chilcoot Pass stuff is thrilling'.[145] Like John Ford, who carefully restaged an 1869 photograph of the ceremony of the hammering of the golden spike that completed the transcontinental railroad for *The Iron Horse* (1925), the film that preceded *The Gold Rush* on location near Truckee as well as at Grauman's Egyptian Theatre in Hollywood the following year, Chaplin made these efforts to duplicate an iconic historical photograph that would have been recognised by audiences. This strict adherence to historical accuracy, however, is immediately contrasted with a shot of the Lone Prospector, who shuffles blithely around an icy precipice wearing a bowler hat and twirling a cane. Unlike everyone in the long line of people just seen climbing the

Recreating the iconic image of the crossing of the Chilkoot Pass on location in Summit, © Roy Export Company Establishment, scan courtesy of Cineteca di Bologna

Chilkoot Pass in lockstep doubled over beneath heavy packs, he has only a bedroll, canteen and pick on his back despite being, as an intertitle reads, 'Three days from anywhere'.

Totheroh confirmed, 'The first idea he had for *The Gold Rush* ... was Chilkoot Pass where they had such hardships and everything, going over this treacherous grade, this mountain called Chilkoot Pass', adding, 'that scene with Mack Swain and the chicken ... was based on the Donner Party cannibalism'.[146] Chaplin riffed comically on the story of the Donner Party to create the scenes in which he cooks up a boot for dinner and it is mistaken for a chicken. In a 1967 interview, he claimed that 'from reading about the Donner party missing their way in the mountains and starving to death, cannibalism, eating shoe strings and everything ... I thought, "Oh yes, there's something *funny* in that" '.[147] Chaplin was an avid reader and his home had a large library, though its contents are not known (and one suspects that many of his books did not make it from California to Switzerland when he abruptly relocated in 1952). Timothy J. Lyons speculates that Chaplin was familiar with C. F. McGlashan's recently reprinted *History of the Donner Party*, pointing out that several elements of the book's account of the Donner Party can be found in *The Gold Rush*.[148]

Although the Donner Party is never directly alluded to in the film, Chaplin tried repeatedly over the course of seven days of shooting and more than 200 retakes between 20 March and 1 April 1924 to work a book that mentions cannibalism into the scenes of starvation in the cabin. In the parts of this planned sequence that were shot and logged with descriptions in the register of scenes kept by Chaplin's production company, the Lone Prospector gives a book to Big Jim, who is raving with hunger, and tells him to read it in order to take his mind off of food. But, what he reads only makes Big Jim think of his companion more as a potential meal since it contains an account of a man who eats his best friend. The sequence was to have ended with the Lone Prospector putting the book into the stove.[149] On 22 and 24 March, Chaplin also filmed shots for a dream sequence

in which he awakens to a feast of turkey and strawberry shortcake prepared and served by Lita Grey, who had appeared several years earlier as an angel for the dream sequence in *The Kid*. These shots were not used in the film since Georgia Hale replaced Grey later in the year.[150] Neither were a number of shots of the Lone Prospector with spots on his face – an aborted idea for depicting a hallucination brought on by hunger.[151]

Another idea that did not make the final cut involved native peoples, who figure prominently in stories of the discovery of gold in the Klondike as well as in later Gold Rush narratives like London's. Eddie Manson recalled shooting 'a sequence ... in an Eskimo village The scene called for nothing but Igloo huts on a barren stage with a sky backdrop cyclorama ... although the ... sequence never appeared in "The Gold Rush"'.[152] In his autobiography, Chaplin writes that in making *The Gold Rush* he

Lita Grey and Chaplin in scenes that were not used in the film, 1924, © Roy Export Company Establishment, scans courtesy of Cineteca di Bologna

was led up many a blind alley, and many amusing sequences were discarded. One was a love scene with an Eskimo girl who teaches the tramp to kiss in Eskimo fashion by rubbing noses together.... But the Eskimo part was cut out because it conflicted with the more important story of the dance-hall girl.[153]

Native peoples were a generic feature of many Northerns – and the subject of *Nanook of the North* (1922) – but Eskimos are practically absent from *The Gold Rush*, with the exception of extras cast and costumed as Eskimos who can occasionally be glimpsed in street and crowd scenes.[154]

A 1925 cutting continuity reveals that one of the final cuts Chaplin made to the film was a scene that was to have come after the Lone Prospector shovels snow to pay for a New Year's Eve supper, but before the festivities at the Monte Carlo Dance Hall. In the sequence, which is crossed out on the continuity, Big Jim has lost his memory (including the location of his secret mine) after being knocked unconscious by Larsen with a shovel. He staggers into the camp of Hank Curtis (Henry Bergman) and his partner, whose tent is

© Roy Export Company Establishment, scan courtesy of Cineteca di Bologna

Reel six. Page three.

#459. S.	#4793	C.U. old man accepts.
#460. S.	#4797	C.C. exits C.U.
#461. S.	#4799	C.C. gets money. C.U.
#462. S.	#4793	Closer up C.C. takes money and starts to dig.
#463. S.	#4802	C.C. digs F.O.
#464. S.	#4804	F.I. C.C. exits towards jail.
#465. S.	#4806	C.U. C.C. jail sign.
#466. S.	#4803	L.S. C.C. exits F.O.
(74) T.	F.I.	Hank Curtis and his partner. F.O.
#467. S.	#4739	F.I. L.S. Henry's mine
#468. S.	#4753	C.U. Henry an partner at stove.
#469. S.	#4739	L.S. Man out of tent starts to feed dogs.
#470. S.	#4743	C.U Man feeding dogs.
#471. S.	#4753	C.U. Henry and partner talking
#472. S.	#4766	L.S. Mack staggers in.
#473. S.	#4760	C.U. Henry sees Mack.
#474. S.	#4766	Man helps Mack to centre. L.S.
#475 S.	#4768	C.U Mack talking to henry and partner.
(75) T.		"Lost! Lost! A mountain of gold. Lost!"
#476. S.	#4768	Henry listens Mack speaks.
(76) T.		"The cabin! I could find my way from the cabin."
#477. S.	#4768	Mack still raving.
(77) T.		"If I could only find the cabin."
#478. S.	#4768	Mack still raving. F.O.
(78) T.	F.I.	New Years Eve. F.O.
#479. S.	#5020	F.I. Int dancehall, crowd having a good time.
#480. S.	#5023	Crowd in dancehall, camera shooting down on them.

Out

A page from the 1925 cutting continuity that shows the elimination of a scene in which Big Jim comes across Hank Curtis and his partner while searching for his lost mine, from the archives of Roy Export Company Establishment, scan courtesy of Cineteca di Bologna

pitched next to their mine. They are feeding their sled dogs. Big Jim raves about his missing 'mountain of gold', then realises, 'If I could only find the cabin' and staggers off to town to look for the Lone Prospector. In later versions of the film, viewers never see Curtis or his partner after they ride off on a dogsled from Curtis's cabin, leaving the Lone Prospector to feed the mule. Other late cuts (also crossed off on the continuity) were the elimination of an intertitle that read, 'Alaska. An enemy to the weak, but to the strong – a friend', which would have been the first shot of the film, and a 'panoram[a] of country'.[155]

Shooting a scene with Big Jim (Mack Swain), Hank Curtis (Henry Bergman) and his partner that was cut late during the making of *The Gold Rush*, © Roy Export Company Establishment, scan courtesy of Cineteca di Bologna

9 Making by Halves; Two Premieres

Chaplin shot *The Gold Rush* in two separate and distinct phases. In the first phase, from February to October 1924, most filming was done in and around cabin sets constructed in the studio, with two weeks in April on location in Summit. These scenes mainly involved Chaplin and Swain (and, to a lesser extent, Tom Murray, Henry Bergman and a number of animals) interacting in claustrophobic all-male environments. The second phase, from January to April 1925, involved dance-hall, street and cabin sets in the studio and a larger group of actors and extras, with three days in April aboard ship filming the scenes with which *The Gold Rush* ends.

Filming ground to a halt when it became clear Grey was pregnant with Chaplin's child – almost nothing was filmed in October, November or December 1924. On 26 November 1924, Chaplin and Grey were secretly married in Guaymas, Mexico, where they travelled on the unlikely pretext of location shooting. (Daily production reports record 1600 feet of film and eighteen stills photographed on 29 November 1924, although none appears to have survived). Grey was then officially dropped from the cast. Several weeks later, on 22 December 1924, screen tests were filmed of her replacement Georgia Hale, who had starred in Josef von Sternberg's recently completed film *The Salvation Hunters* (1925). Filming began again with Chaplin, Hale, Malcolm Waite and a number of extras in the Monte Carlo Dance Hall set on 2 January 1925.

The two distinct phases of shooting *The Gold Rush* roughly correspond to the two archetypal indoor Northern settings Chaplin used for the film: cabin and dance hall.[156] He linked these iconic settings with the snow scenes that defined the genre. Gerald Mast describes the plot of the film as a 'circle' that alternates between these two types of locations: 'Prologue (the trek North), the Cabin, the

CHARLIE CHAPLIN FILM CO.		DAILY PRODUCTION REPORT			NUMBER OF DAYS ON PICTURE INCLUDING TO-DAY		
					IDLE 164	WORK 93	TOTAL 257
DIRECTOR	CHARLIE CHAPLIN			DATE	November 1		1924
CAMERAMAN	Roland Totheroh & Jack Wilson.			PICTURE No.			
WORKING TITLE	"GOLD RUSH"			NUMBER OF REELS			

CAST	RATE	SCENES PLAYED IN	PETTY CASH EXPENDITURES	
			ARTICLE	AMOUNT
			BALANCE ON HAND	
Henry Bergman				
Mack Swain.				
Tom Murray				
Fred Karno				

STILLS TAKEN TO-DAY: 600
(These 18 stills are Mexican scenes) NUMBER BROUGHT FORWARD 18
Film report November 29th. TOTAL STILLS TO-DATE 618

SCENES TAKEN TO-DAY						FILM USED		STARTED WORK	
SCENE NO.	FEET	SCENE NO.	FEET	SCENE NO.	FEET	FOOTAGE		A. M.	P. M.
		FORWARD		FORWARD		TO-DAY	120442		
						BAL. FORWD.	1600	(Tests) Mexico scenes.	
						TOTAL TO DATE	122042		
						MEMO. Scenes shot while in Mexico on location. (Film Report November 28th.)			

WEATHER: FAIR / CLOUDY / RAIN

O.K. *Kathleen Pryor* CLERK

Most of the daily production reports for October, November and December 1925 indicate that no filming was done, but this one records location shooting in Mexico where Chaplin had travelled to marry Grey in secret. From the archives of Roy Export Company Establishment, scan courtesy of Cineteca di Bologna

Dance Hall, New Year's Eve, the Dance Hall, the Cabin, the Epilogue (the trek home)'.[157] If *The Gold Rush* involves a circuit of generic Northern settings, it is also among Chaplin's films that have 'generic titles'. As Mast writes, 'The films are not structured around stories – what happens to the characters – but around an investigation of the theme implied by the title'.[158]

The title of *The Gold Rush* evokes the pursuit of material wealth. But, unlike Erich von Stroheim's *Greed* (1924), in which gold is fetishised and its accumulation eventually overwhelms all else, gold appears only briefly in *The Gold Rush* and the Lone Prospector – despite his moniker – evinces little visible interest in finding it. The relative absence of gold and the labour needed to locate it and extract it from the earth is certainly part of the point of the film, which dispenses almost entirely with prospecting, mining and all the potentially productive activities depicted in non-fiction films about

the Gold Rush. Instead, *The Gold Rush* explores the comic possibilities of 'putting the wandering *picaro*, the homeless tramp (or some variation of him) in juxtaposition with a particular social and moral environment. The film's structure is based on this juxtaposition', Mast points out.[159]

The juxtaposition between character and environment emerges most clearly in the scenes in the Monte Carlo Dance Hall. Untutored in its social rules and roles, the Lone Prospector is even more of an interloper in the dance hall than in the snowbound cabin. The cabin scenes in *The Gold Rush* take place in an atavistic environment where small groups of men concerned primarily with food and shelter struggle for survival, often in close contact with wild, or only partly domesticated, animals. By contrast, the scenes in the dance hall occur among a group of people defined by a hierarchical social order, mutually exclusive gender roles and distinct occupational positions. Entering the Monte Carlo, the Lone Prospector stands on the threshold of the dance floor and lingers there as couples begin dancing, observing everything as an outsider

Sid Grauman, Chaplin and Lita Grey playing around on location, © Roy Export Company Establishment, scan courtesy of Cineteca di Bologna

– just as he does when he returns on New Year's Eve to peer through a frosty window but never enters. His participation in what goes on in the dance hall proves to be incongruous and immediately disruptive. Before leaving the Monte Carlo his first night there, he takes a drink without paying for it, drags a large dog from beneath a table onto the dance floor (mistakenly using its dangling rope leash to hold up his sagging trousers) and is involved in a scuffle.

The 1925 premieres of *The Gold Rush* in Hollywood and New York mobilised several conventions of the Northern. Both premieres involved theatrical prologues that preceded the screening of the film. The Hollywood premiere took place on 26 June at Sid Grauman's Egyptian Theatre. Grauman, who had been in Dawson City for the Gold Rush before becoming a theatrical entrepreneur, had been friends with Chaplin since Chaplin's 1911 appearances with Karno's comedy troupe at Grauman's Empress theatre in San Francisco.[160] Grauman went on location with Chaplin for *The Gold Rush* and may also have supplied him with ideas for the film. According to Joyce Milton, 'Grauman ... once circulated a script about the Klondike written by an old prospector friend' that might have been a source for *The Gold Rush*; 'a number of studio regulars assumed that the film was inspired by his anecdotes'.[161] Shortly before *The Gold Rush* was released, however, Grauman was distressed to discover that Chaplin had sneak previewed the film a month earlier at another theatre.[162]

It took nearly a week to prepare the Egyptian Theatre for Grauman's elaborate prologue, which involved more than 100

A page from the programme for the Hollywood premiere of *The Gold Rush* at the Egyptian Theatre outlining Sid Grauman's prologue

```
GOLD RUSH
Prints                         SALES MANAGERS

 8  ATLANTA        GA.         T. E. DILLARD          106 WALTON STREET
10  BOSTON         MASS.       H. T. SCULLY           69 CHURCH STREET
 4  BUFFALO        N.Y.        W. L. SHERRY           365 FRANKLIN STREET
47  CHICAGO        ILL.        C. G. WALLACE          804 WABASH AVENUE, SOUTH
 4  CINCINNATI     OHIO        W. A. SHALIT           503 BROADWAY FILM BUILDING
 8  CLEVELAND      OHIO        M. SAPIER              2143 PROSPECT AVENUE
 8  DALLAS         TEX.        J. E. LUCKETT          308 SOUTH HARWOOD STREET
 6  DENVER         COLO.       J. A. KRUM             2044 BROADWAY
 8  DETROIT        MICH.       H. W. TRAVER           303 JOSEPH MACK BUILDING
 8  KANSAS CITY    MO.         GUY F. NAVARRE         1706 BALTIMORE AVENUE
 8  LOS ANGELES    CALIF.      F. E. BENSON           922 SOUTH OLIVE STREET
 6  MINNEAPOLIS    MINN.       T. J. MAC EVOY         503 LOEB ARCADE BUILDING
 4  NEW HAVEN      CONN.       H. M. MASTERS          134 MEADOW STREET
51  NEW YORK       N. Y.       M. STREIMER            729 SEVENTH AVENUE
 4  OMAHA          NEBR.       P. D. MC CRACKEN       1508 DAVENPORT STREET
12  PHILADELPHIA   PA.         JNO. HENNESSY          1333 VINE STREET
10  PITTSBURGH     PA.         C. E. MOORE            1014-16 FORBEST ST-UPTOWN P.O.
    PORTLAND       MAINE       M. J. GARRITY          614 FIDELITY BUILDING
 6  ST. LOUIS      MO.         WM. A BARRON           3333 OLIVE STREET
 6  SALT LAKE CITY UTAH        CARL SHAAN             56 EAST 4th SOUTH STREET
 8  SAN FRANCISCO  CALIF.      WALTER S PAND          329 GOLDEN GATE AVENUE
 8  SEATTLE        WASH.       C. W. HARTEN           1915 THIRD AVENUE
 6  WASHINGTON     D. C.       J. T. CUNNINGHAM       801 MATHER BUILDING
    CALGARY        ALTA        L. C. SMART            TRADERS' BUILDING
    MONTREAL       CANADA      I. SOURKES             12 MAYOR STREET
    ST. JOHN       N. BRUNS.   W. H. GOLDING          153 UNION STREET
10  TORONTO        CANADA      J. BERMAN              6 DUNDAS STREET, WEST
    WINNIPEG       CANADA      C. M. WEINER           403 FILM EXCHANGE BUILDING
    HAVANA         CUBA        ENRIQUE BAEZ           R. M. DE LABRA 39 & 41
    MEXICO         D. F.       HARVEY SHEAHAN         DESP. 110-115, CALLE DE SAN
                                                      JUAN DE LETRAN # 6

Prints

(70  England              Maurice Silverstone, G. M.      London, England
(    These are to be shipped to New York for re-shipment to England, that is, ship
     to the Home Office, 729 Seventh Avenue, New York City.

(40  Continental Europe   Guy C. Smith, G. M.             Paris, France.
(    These are to be shipped to New York for re-shipment to the Continent, that is
     ship to the Home Office, 729 Seventh Avenue, New York City.

TOTAL    360 Prints.
```

A typewritten list of destinations for 360 positive prints of *The Gold Rush* struck in 1925, from the archives of Roy Export Company Establishment, scan courtesy of Cineteca di Bologna

performers and was seventy minutes long.[163] Opening night began with a long procession of Hollywood notables, who were announced as they took their seats. Gino Severi then conducted a 'medley of semi-classical numbers' played by the theatre orchestra and next actor Tyrone Power recited Robert W. Service's poem 'Spell of the Yukon'. Scenery depicted the Chilkoot Pass in the background, with 'blue floodlights and falling snow ... to portray the Ar[c]tic setting'. The stage setting was an Eskimo village, and the prologue began when an actor dressed like Chaplin entered; several Eskimos performed an Eskimo dance and showed him Eskimo games. The ersatz Chaplin then fell asleep, motivating a series of dances and an ice-skating number. A special set then moved into place, 'an exact replica of the dance hall shown in the picture' where 'three old time ballads and a clog dance were staged'.[164] The prologue ended with a group of prospectors mounting the Chilkoot Pass, waking up the tramp sleeping beside the path. Although Joseph Plunkett's prologue for the New York premiere at the Strand Theatre on 16 August was shorter (as was *The Gold Rush* by that point), it also centred on a set modelled on 'The Monte Carlo Dance Hall'.[165] After opening in London at the Tivoli Theatre on 14 September and Paris at the Salle Marivaux on 22 September, *The Gold Rush* entered general distribution: 250 prints were dispatched to different cities across the United States, seventy prints were sent to England and another forty to continental Europe.[166]

10 Revising and Reviving

The Gold Rush could be seen from time to time after its initial release in some places, but in 1933, Chaplin instructed United Artists to withdraw prints of all of his silent features from distribution because, according to Alf Reeves, 'the bookings lately have fallen to such low rentals there is not much use in continuing. They will be better for a reissue – if and when'.[167] By the early 1930s, a few silent films had been reissued with synchronised music soundtracks and sound effects, including perhaps most notably *The Birth of a Nation* (1930). In 1932, the films Chaplin made at Mutual in 1916–17 were released with music soundtracks by the Van Beuren Corporation and continued to be part of film programmes for years afterward.[168] On 10 February 1934, while Chaplin was making *Modern Times*, Reeves wrote Syd Chaplin,

> Charlie decided to discontinue offerings of 'Woman of Paris', 'Gold Rush' and 'Circus' and we have notified United Artists. The returns were quite unimportant… . I might tell you that we have considered at various times that these pictures should be synchronized. In fact we went into detail for 'Gold Rush' – to re-issue through United Artists a new synchronized version (sound effects and music) but Charlie did not go on with it, and of course he will not do so now – at any rate, until the new picture is off his hands.[169]

During the next decade, Chaplin's production company declined a number of requests to rent, purchase and redistribute silent 16mm and 8mm prints of *The Gold Rush*, while actively investigating unauthorised copies and showings. In a letter of 2 May 1938, Reeves suggested to Arthur Kelly that Chaplin had 'given up any idea of "The Gold Rush" revival'.[170] Having already deferred the project for four years, it was another three years before Chaplin turned his attention to reviving *The Gold Rush*.

On 18 June 1941, according to weekly production reports, Chaplin started work on the sound version of *The Gold Rush*. The first task was re-editing the film, much of which took place over the course of the next several months, but initially proceeded somewhat sporadically since Chaplin was away from the studio many days (some of which he spent with his son Charles Chaplin, Jr. on his yacht). On 23 August, composer Max Terr joined the project; work on the music began in earnest at the studio while the re-editing continued. Over the next two months, the score was 'composed at the Steinway grand piano in the studio projection room by Chaplin and Terr, while "The Gold Rush" was run and re-run hundreds of times on the screen before them'.[171] Sound recording began on 15 October at the RCA studios in Hollywood and continued until 5 January 1942, when final retakes were recorded. Terr conducted the forty-one-piece orchestra, which was recorded mostly during evenings at RCA. Chaplin's relentless pursuit of perfection led to a number of long nights and the use of many miles of soundtrack negative. The final push to finish the score was made over the weekend of 1 to 2 November 1941, when Chaplin, Terr and the musicians were at work from Saturday at 2 p.m. until 4 a.m. on Sunday and from 6.30 p.m. Sunday until 5 a.m. on Monday. Sound editing was done at Chaplin's studio in November and December, with several additional days in December dedicated to music retakes. On 1 December, a twenty-six-person choir selected by Terr rehearsed and sang 'Auld Lang Syne' to accompany the New Year's Eve scene. From 10 to 12 December, Chaplin was back in his studio filming 'scenes for new beginning and new ending of picture, also new main title for same'. The new main title was used for *The Gold Rush* (1942), but the new scenes, which involved the construction of a set and would have bookended the film, were not.

The 'music and descriptive dialogue added' (as the opening titles for the sound version put it) were recorded at RCA during the last few months of 1941. Chaplin revised the narration, like the music, continually throughout the process, leading to many retakes.

In the finished film, Chaplin speaks all of the words in voiceover. His spirited monologue provides information about setting and character, while delivering some of the ostensible dialogue of characters (including his character, the Lone Prospector) in the third person. This type of narration dates back to early cinema, when lecturers in the exhibition space accompanied projected images with verbal descriptions, explanations and commentary. Chaplin adopts the 'third-person narration' lecture style and emphasis on a '"connected narrative"' recommended for lecturers of the early 1900s, but he also adds verbal humour and irony through wording and delivery.[172] In a few cases, Chaplin's narration matches the text and relative placement of an eliminated intertitle, but in most places the wording was either modified substantially or newly written for the revival.

The removal of the intertitles created noticeable jump cuts in the sound version in places where intertitles had been placed within – rather than between – takes. When Chaplin remarked on this, 'Rollie Totheroh replied: "There are no jumps in the negative. That was in the cutting."' In those places where there was 'too much of a jump through eliminating the title' or shots contained 'too many jumps', Chaplin instructed Totheroh to substitute alternative takes. Notes that survive from these sessions (many of which took place in the screening room at Chaplin's house) indicate that close-up shots were added, presumably for purposes of continuity, and other shots substituted for reasons that are not always clear.[173]

The most substantial changes to the film fundamentally altered the relationship between the Lone Prospector and Georgia. In revising the film, Chaplin transformed their relationship from one of asymmetrical unrequited affection into a blossoming romance. In most silent versions, Georgia is scornful of him and only reciprocates his affections when they are both on board a ship setting sail from Alaska. Asked to wear his 'mining clothes' for a newspaper photograph, he is mistaken for a stowaway, but Georgia tries to hide him from the ship's officers by shoving him into a large coil of rope. Discovered there, she offers to pay his fare before discovering that he

is a multimillionaire. They go with the reporter and the photographer to pose for a photograph together on an upper deck, and kiss the moment the picture is taken.

This conventional ending is undercut by the staging of the photograph (the Lone Prospector is instructed to get into costume and pushed closer to Georgia as they pose) and the reporter's comment, 'This will make a wonderful story', both of which remind us of the conventions that shape visual and narrative fictions. The romantic clinch is not entirely motivated by the story that precedes it and the happy ending ultimately seems ironic, with the photographer exclaiming with dissatisfaction that the kiss has 'spoilt the picture'. Much like the sudden discovery of gold that immediately precedes it, the final shipboard sequence has the tacked-on quality of the last scene of *The Last Laugh* (1924). The beginning of the sequence, a tracking shot of the Lone Prospector and Big Jim striding toward the camera on the deck of the ship in brand new fur coats and top hats

(*left*) © Roy Export S.A.S.; (*right*) © Roy Export Company Establishment

76 | BFI FILM CLASSICS

A silent version, © Roy Export Company Establishment; the sound version, © Roy Export S.A.S.

recalls the sudden reversal of fortune seen in the final scene of *The Last Laugh* as well as its use of a moving camera. In his autobiography, Chaplin claimed to 'loathe tricky effects ... [like] travelling with an actor through a hotel lobby as if escorting him on a bicycle' – a seeming allusion to *The Last Laugh* – and dismissed such 'pompous effects ... [which] have been mistaken for that tiresome word "art" '.[174] Here, he uses them to underscore the essential irony and ambivalence of the film's ending.

In the sound version, however, a romantic relationship between 'the little fellow' and Georgia develops much more plausibly. Although not fully reciprocal, their feelings for one another seem a bit more mutual from their first meeting. Absent is the scorn that characterises many of Georgia's interactions with the Lone Prospector in silent versions. This has the effect of partly tempering the melancholy that infuses his character. In silent versions, after Georgia slaps Jack in the face at Hank Curtis's cabin, she sends him a note of apology in the dance hall. Jack cruelly has a waiter pass the unaddressed note along to the Lone Prospector, who believes that Georgia is apologising for missing the New Year's Eve dinner he prepared for her and her friends. In the sound version, Chaplin substituted a new insert shot showing an apology note that is unambiguously addressed to the Lone Prospector. Chaplin also removed the irony of the film's happy ending – and, with it, the conventional kiss that ends most silent versions. Indeed, *The Gold Rush* (1942) ends with Georgia and the Lone Prospector walking offscreen holding hands, immediately followed by a title printed in script that reads 'Finis'.

11 Second-Best Ever

While reviews of *The Gold Rush* in 1925 had generally been favourable, critical response to *The Gold Rush* (1942) was overwhelmingly and almost uniformly laudatory. Reviewers praised the voiceover narration; the consensus was 'the commentary at times is as funny as some of the gags, and the musical score ... is just right'.[175] Reviews almost invariably compared the sound version to memories of a silent version, often singling out specific scenes. The sound version of *The Gold Rush* was nominated for two Academy Awards (for musical score and sound recording). Its critical and commercial success inspired Chaplin to consider reviving *The Circus* (1928) along the same lines, while Harold Lloyd planned a similar treatment for *Safety Last* (1923) – although neither eventually happened.[176]

For some critics, *The Gold Rush* (1942) was a welcome departure from recent Chaplin films, a return to the 'days when Charles Chaplin was still Charlie Chaplin, still content to be just a comedian, a magnificent comedian, and not a philosopher who wanted to save the world.... "The Gold Rush" is pure comedy'.[177] Wartime critics who preferred their comedy 'pure' and apolitical praised *The Gold Rush* (1942) as a delightful throwback to the Chaplin they fondly remembered as having formerly 'made pictures for sheer entertainment' (as Wanda Hale wrote in the *New York Daily News*).[178] Critics like these, who praised *The Gold Rush* (1942) as Chaplin's long-awaited return to 'pure comedy' and 'sheer entertainment' glossed over the film's satire on the acquisition of wealth and overlooked the longstanding class valences of Chaplin's tramp character.[179] Their responses foreshadowed the political backlash against Chaplin that intensified during the Joan Barry paternity scandal. One of the 'two primary gossip columnists to take

up pens against Chaplin', perhaps not coincidentally, was 'Florabel Muir (of the *New York Daily News*)', who provided information to the Federal Bureau of Investigation for its ongoing investigation of Chaplin.[180] Criticism of Chaplin, which was often linked to his political progressivism, became increasingly vituperative during the Cold War – part of what Charles Maland describes as the 'unraveling' of Chaplin's star image in the United States after the release of *Monsieur Verdoux* (1947).[181] During an especially contentious press conference in New York on 12 April 1947 ostensibly about *Monsieur Verdoux*, one questioner gave voice to this critique of Chaplin, telling him, 'you have stopped being such a good comedian since your pictures have been bringing messages – so-called'.[182]

The Gold Rush (1942) may have satisfied those who wanted more anodyne film comedy, but it also elicited general nostalgia for an ostensibly more innocent time. Writing just after the German occupation of Paris ended in 1944, André Bazin took this tack in reviewing *The Gold Rush* (1942), which had been banned by the Nazis. Like most critics, Bazin thought the sound version was 'sensational' and claimed that the film's use of spoken commentary was proof positive Chaplin was not 'hostile to speech'. His review conflated joyful memories of seeing *The Gold Rush* as a young person with nostalgia for life before the war. He concluded, 'Before [seeing *The Great Dictator*], go see again the good-hearted black-and-white of our childhood innocence – the Chaplin before we found out that somewhere in Europe a housepainter had stolen his moustache'.[183] (Bazin returned to the similarity between Chaplin's moustache and Hitler's moustache in an article the following year that described the late fascist dictator as a bad Chaplin imitator.)[184]

In 1942, critics focused on the very same sequences that their counterparts had highlighted in reviews of *The Gold Rush* in 1925, many of which they assumed would be familiar to readers, but 'the eating of the boiled shoe' was now one of several 'timeless delights',

along with 'the classic episode in which he does a dance with two rolls impaled on forks' and several other scenes.[185] With its revival, *The Gold Rush* became 'timeless' and a 'classic', disconnecting the film from both the history and the Northern genre that inspired it. John T. McManus was one of very few 1942 critics to describe it as a parody or link it to other previous Northerns, noting 'The characters of *The Gold Rush* are caricatures of the men of our tall-story legends'.[186] During the 1940s, the film was transformed from a generic parody into an exemplar of the 'genre' that Siegfried Kracauer identified as 'silent film comedy' – the *ex post facto* category that would subsequently be used to classify *The Gold Rush* more than any other.[187]

In 1942, at least one critic deemed it 'One of the greatest and funniest films ever made', but *The Gold Rush* became a canonical film during the 1950s through a series of polls that asked filmmakers and film critics to rank the best films of all time.[188] When the Festival Mondial du Film et des Beaux Arts de Belgique invited '100 film personalities, mostly directors' to submit their personal top ten lists, *The Gold Rush* received the second-most votes, after *The Battleship Potemkin* (1925). Among the voters, Robert Bresson had *The Gold Rush* #1, Luis Buñuel ranked it #2, Elia Kazan had it #3 and Carl-Theodor Dreyer and Billy Wilder both ranked it #4.[189] Later that year, the publishers of *Sight & Sound* polled a group of international film critics. Again, *The Gold Rush* got the second-most votes, tied with *City Lights*, after *Bicycle Thieves* (1948).[190] In 1958, the Cinémathèque de Belgique attempted to bridge the preferences of critics and film-makers through a two-step process that culminated at the World's Fair in Brussels. First, 117 film historians each composed a list of the thirty 'most important' films made before 1955. The twelve films receiving the most votes were projected at the Exposition, 12 to 18 October 1958, for a final vote. *The Gold Rush* was among the twelve, receiving the second-highest number of votes from the film historians, tied with *Bicycle Thieves*, after *The Battleship Potemkin*.[191] But, when the final jury of 'young

film-makers' was asked to designate 'the best' of these twelve films, its members demurred, instead naming six that 'for us as film-makers, have a living and lasting value'.[192] One of the half-dozen best was *The Gold Rush*, although it is not clear which version the jury saw or was voting upon.

12 Un/Authorised Versions

In 1952, Chaplin's re-entry permit was revoked after he left the United States to travel to London for the world premiere of *Limelight*. Unwilling to answer to immigration officials, he decided not to return and relocated the following year to Corsier sur Vevey, Switzerland, leaving behind both his Beverly Hills home and his Hollywood studio. In closing down the studio, Chaplin instructed Totheroh to destroy what was left in the studio vaults, including numerous outtakes. David Robinson notes that 'Totheroh ... was no longer young and not well and ... did not do the job very efficiently'.[193] In this way, some of Chaplin's extra film footage survived, only to be discarded by the next occupants of the property – television producer Kling Studios, which (as the company explained in a 1954 advertisement) made use of the 'famous Charles Chaplin studios ... for TV shows and commercials; industrial, training and institutional films for business and industry'.[194] Paolo Cherchi Usai explains,

In February, 01954 [sic], the Chaplin Studio on La Brea Boulevard in Hollywood was handed over to its new owners, who planned to outfit it for TV production. The faithful Rollie Totheroh had shipped many negatives and prints over to Switzerland, but much still remained. The new owners ... emptied out the film vaults, where the outtakes from nearly forty years were stored. Some of the material was saved by Raymond Rohauer and ... some was not.[195]

Robinson estimates that '[s]everal hundred reels survived and eventually came into the possession of distributor Raymond Rohauer'.[196] Rohauer recalled purchasing about 'two hundred and thirty [oil] drums' packed with Chaplin films from an unnamed seller.[197] These oil drums apparently contained outtakes from *The Gold Rush*.

THE GOLD RUSH

Variety, 3 February 1954

Rohauer claimed to have reconstructed a silent version of the film entirely from outtakes. Interviewed by Kevin Brownlow and David Gill, he said:

> There were no known prints of the 1925 version. Only the 1942 reissue. I just decided to go through all the reels and make it up from the outtakes. I had a few reels of cutting copy, and I worked with a professional editor I found the original titles. Where there was no cutting copy, we just had to take from these huge rolls scenes that we thought would match. If you really look at it, it doesn't match. It probably doesn't match the original film at all. But no one ever knew.[198]

Rohauer's claim to have made a version of *The Gold Rush* from Chaplin's outtakes is not so different from what Chaplin himself did in 1943 when he assigned Totheroh the job of 'assembling new negatives' of his First National films. Robinson writes,

> Totheroh spent most of the next year or so preparing these definitive negatives and library prints of the First National Films. They were to prove invaluable years later when Chaplin decided to reissue a number of his early films with music. Chaplin's almost obsessive habit of retaking every shot until he was completely satisfied meant that Totheroh could reconstruct near-identical versions of practically every moment of the films. Inevitably there are slight but constant variations between the original versions and the new 1940s negatives, which provide constant fascination and frustration to students and critics.[199]

One unintended result of Chaplin's perfectionism was the creation of a quantity of material so great and so similar that multiple versions could be created and recreated while the outtakes were still in existence.

In 1954, Rohauer copyrighted a 16mm version of *The Gold Rush* under his own name, claiming the addition of 'new matter, rearrangement of sequences'.[200] Rohauer built up an extensive

catalogue of silent films by making copies of films loaned to him by museums and collectors, while exploiting copyright lapses, international differences in copyright law and often dubious ownership claims.[201] Rohauer seems to have dealt both in silent versions of *The Gold Rush* as well as in unauthorised copies of Chaplin's sound version.[202] Rohauer's silent prints of *The Gold Rush* appear to have served as the direct or indirect sources for many subsequent copies, including the unauthorised prints distributed in several different formats by Paul Killiam (some of which he also tinted) and two 35mm prints with music soundtracks and German intertitles that were confiscated in Germany in 1962 after Chaplin successfully sued the distributor, Atlas Films.[203] In reporting Chaplin's legal victory in a Frankfurt court of law, *Variety* noted, 'When Chaplin sold his studios in the U.S., much of his surplus film material was to be destroyed, and was sold to a firm for burning. Instead, some copies of the old Chaplin classics wound up in private hands'.[204]

While silent versions of *The Gold Rush* were in the American public domain, they were widely seen on film, television, videocassette and laserdisc. On 6 July 1971, Orson Welles introduced *The Gold Rush* on public television station WNET New York as part of the series 'The Silent Years'. Although the broadcast got 'a higher score than any of public television's network offerings have ever drawn in New York', these unprecedented high ratings were still below those of the latest episodes of *Hee Haw* and *All in the Family* broadcast on CBS at the same time.[205] By 1977, some twenty-five different distributors offered silent 16mm prints of *The Gold Rush*, which could also be

A silent version of *The Goldrush* (sic) distributed on laserdisc by Killiam. Donald Hall Collection

obtained in 8mm and in super-8 (some tinted and/or accompanied by music).[206] At least as many distributors sold unauthorised videocassette copies of *The Gold Rush* during the 1980s and 1990s.

In 1978, Andre Blay purchased the video rights to the only version of *The Gold Rush* that was authorised at that time – the sound version – for Magnetic Video, which packaged it with the Chaplin short *Pay Day* (1922) for sale on videocassette.[207] Several other distributors released this version subsequently on videocassette and laserdisc.[208] The silent version of *The Gold Rush* reconstructed by David Gill and Kevin Brownlow made extensive use of a full aperture negative of the authorised sound version since it was of 'excellent quality'.[209] But, it also includes previously unauthorised material from prints distributed by Rohauer and Killiam.[210] Given this mixed provenance, it is impossible to say which parts of the reconstructed version, *The Gold Rush* (Charlie Chaplin, 1925; Charles Chaplin, 1942; David Gill and Kevin Brownlow, 1993) would correspond to what audiences saw in 1925. First screened publicly in 1993, the reconstructed silent version was made available on DVD ten years later, along with the sound version.[211] Since 2012, the Criterion Collection has distributed both versions of *The Gold Rush* on DVD (and in Blu-ray high definition). Both can also be streamed online for playback on computer screens, tablets and portable devices.

The authorised sound version of *The Gold Rush* on video

13 Memorable Sequences

While completing *The Gold Rush* in 1925, Chaplin claimed 'there isn't a single gag in the picture ... except for those that proceed directly out of the story itself'.[212] This remark seems disingenuous because, as we have seen, the conception and the execution of several specific gags preceded the construction of a cogent narrative. Indeed, Chaplin started with a conception of the story that was loose enough to accommodate a number of different generic possibilities, and the story appears to have cohered fairly late during the process of making the film. For critics of 1925 like Jean Moncla, its modular construction betrayed a somewhat uneven film: 'The different cells which make it up are not always fused together with perfect precision – the joints are visible and the whole lacks unity. But each fragment considered in isolation attains perfection'.[213]

In a perceptive 1925 review of *The Gold Rush*, Iris Barry avoided discussing the 'improbabilities' of its story and instead focused on what was memorable about the film:

unlike most situations and figures on the screen, these in *The Gold Rush* come up fresh in the memory when the film is over, and do not, as too much on the films does, fade away, rejected by the mind which cannot be bothered to recall such meaninglessness.[214]

For Barry, two scenes were especially noteworthy – 'when he has most kindly boiled one of his famous boots for a starving miner-pal and serves it up after due testing with a fork' and the 'superb bit of "footwork"' with which he 'dance[s] "The Oceana Roll"'.[215] Along with these two scenes, two others are frequently referred to in reviews of the film: the scene in which Big Jim imagines his cabin-mate is a chicken and the scene in which the cabin they are

inside is perched precariously on the edge of a cliff after being blown there by a storm.

Working out the latter sequence, which became the climactic scene of the film, was one of Chaplin's earliest challenges in making *The Gold Rush*. Before she was signed as Chaplin's co-star, Grey recalled visiting Chaplin's studio and finding him at work on an 'interesting technical problem'. He and his collaborators were rigging a cabin set with 'a complex series of pulleys' so it 'would look as if it were teetering precariously over the edge of a precipice'.[216] They spent several months trying to find a satisfactory solution for depicting the interior of a cabin perched unsteadily on a cliff. Grey explained the eventual arrangement used for this sequence:

The cabin was a set inside the studio. The floor of the cabin set was set on top of a pivot. The set was given further malleability by the hinges built into the walls and roof, and the swaying effect was made complete by the crew pushing the cabin back and forth outside camera range. In the sequence where the cabin is actually slipping off the cliff, the cabin set was suspended in the air by an elaborate system of cables and pulleys. The crew would make the house slip a bit each time the Tramp would cough or sneeze.[217]

An article in the December 1925 issue of *Science and Invention* magazine explained how the scene was filmed, complete with several diagrams.[218] The solution involved a set that tipped to create, as one review noted, 'a situation replete with thrills and comedy on the screen, but impossible on the stage and unconvincing in print'.[219] The sequence required careful choreography of Chaplin and Swain's movements in concert with the rocking of the cabin set. They move about the cabin – nonchalantly at first, then more tentatively – before realising that their relative positions (and their respective weight differences) are keeping the floor either level or at an angle. As it appears in the film, this sequence depends on cross-cutting between cabin interiors shot on the moving set and exteriors filmed with miniatures.

Tension escalates as the cabin rocks back and forth, but the occupants remain ignorant of their seesaw-like predicament. Cross-cutting makes the viewer immediately aware that the cabin is on the edge of a cliff, but much of the scene's comedy comes from the fact that the cabin's occupants do not know what is going on – an idea that Totheroh credited to a suggestion made by Monta Bell.[220] The Lone Prospector believes that their stomachs are the cause of the unsteady feeling. (*Science and Invention* specifies drinking the night before as the reason for weak stomachs: 'arriving at the cabin, they spend the night, after having imbibed rather freely of a canteen of liquor'.)[221] After several tries, the Lone Prospector manages to force open the back door of the cabin to see what is outside, but ends up dangling over the abyss clinging to the doorknob of the swinging door. Only then do he and Big Jim realise that the cabin is on the edge of a cliff, at which point it slides further and is only prevented from falling off by a rope tied to the chimney, the knotted end of which fortuitously lodges itself between two rocks.

Perched on the edge of a cliff, the floor of the cabin is pitched at a steep angle that gets steeper as the cabin slips further over the brink. Fearing that movement will unmoor the structure, Big Jim and the Lone Prospector try to remain still, but the cabin continues to slip. They each try to scramble up the floor to the front door, but nearly slide through the open back door in the process. Only when the Lone Prospector braces his feet on the back wall and Big Jim stands on the smaller man's shoulders is he able to crawl out to safety. In a true *deus ex machina*, the location of Big Jim's lost claim is right beside the rocks in which the rope holding the cabin is wedged. Big Jim is ecstatic and momentarily forgets that his companion is still inside the cabin, which continues to slip. Realising this, he throws the Lone Prospector a rope and pulls him through the front doorway just as the cabin falls from the cliff. These shots involved double exposing shots of a cabin model on a cliff with extreme long shots of the performers. Visual effects like these embed Chaplin's performances within a virtual space (and a virtual temporality) created technologically with editing and multiple exposures.

The earlier scene in which Big Jim imagines that his cabin-mate is a giant chicken depicts his hallucination through several dissolves. As the Lone Prospector makes his way around the cabin, Big Jim imagines that he is a chicken and eyes him hungrily. A series of seamlessly matched dissolves between the Lone Prospector and the imagined giant chicken depict Big Jim's hallucination without ever strictly adopting his visual point of view. With a chuckle, Big Jim says, 'I thought you was a chicken' (which becomes the grammatically correct 'I thought you were a chicken' in Chaplin's narration for the sound version). Still deluded by hunger, Big Jim draws a knife and chases the Lone Prospector out of the cabin. Eddie Sutherland recalled that the sequence only came together when Chaplin (rather than Pete Stich, 'the painter at the studio')

reluctantly got into the chicken skin. But when he got into the chicken skin, he was a chicken. Every move was a chicken's' ... he knew just

what a chicken did and how it moved its wings and its feet and everything else.[222]

Indeed, the use of dissolves and a giant chicken costume in this sequence are secondary to Chaplin's chicken-like pantomime of strutting, preening, flapping and running.

 This scene literalises a visual metaphor, like the scene that immediately precedes it, in which the Lone Prospector eats part of one of his boots for Thanksgiving dinner and serves the other part to Big Jim. The Lone Prospector puts the boot on a plate, which he makes sure to brush off so it is clean. He then serves the laces like a length of pasta and carefully separates the upper from the sole, exposing the nails. He takes bites of the sole, eats the lace wound around his fork with relish and sucks on each of the nails with satisfaction, extending one to Big Jim like a wishbone. Seemingly sated, he belches several times. Eddie Sutherland recalled, 'The shoe-laces were made of licorice, the shoes were made of licorice, the nails were made of some kind of candy'.[223] Chaplin filmed so many

Eddie Sutherland with Chaplin in the chicken suit on location, 1924, © Roy Export Company Establishment, scan courtesy of Cineteca di Bologna

retakes that both he and Swain reportedly suffered indigestion as a consequence.

Consistent with Chaplin's defining theme of hunger, many scenes in *The Gold Rush* are concerned with food. The best remembered of these scenes involves neither consuming nor fantasising about food (or its substitutes), however, but instead playing with food. After the Lone Prospector, who is staying in Hank Curtis's cabin, sets the table for a celebratory New Year's Eve supper, he falls asleep at the head of the table waiting for his guests to arrive. With a dissolve, four dance-hall girls are seated at the table – Georgia on his right – laughing and wearing party hats. Rather than give a speech, he dances the Oceana Roll by spearing two rolls with forks and manipulating the forks like little legs beneath his chin in an elaborate series of 'dance' moves. The dance-hall girls applaud and Georgia gives him a kiss, but another dissolve returns the Lone Prospector to a solitary New Year's Eve in an empty cabin. As in the chicken scene, dissolves mark the passage from

real space to mental space, bracketing the dream sequence of *The Gold Rush* (which also occurs during a meal). Totheroh made the dissolves in-camera, which required careful positioning of the actors and other parts of the *mise en scène* so that the transitions were smooth.

Chaplin had performed in a dream scene in the comic sketch *Jimmy the Fearless, or the Boy 'Ero* when he was with Fred Karno's troupe in 1910. In a plot that resembles the Biograph film *Terrible Ted* (1907), the eponymous Jimmy reads a penny dreadful,

> Then the sketch moves into the dream-world and Jimmy is seen performing amazing feats of daring-do in the face of incredible perils. He rescues lovely girls tied down to railway lines, defeats a horde of Red Indians, discovers vast treasures, and is about to marry his fairy princess when ... he wakes up.[224]

Stan Laurel, whom Chaplin replaced in the sketch, credited *Jimmy the Fearless* with Chaplin's interest in dream sequences.[225]

© Roy Export S.A.S., scan courtesy of Cineteca di Bologna

The dance of the Oceana Roll is the centrepiece of the dream sequence, which was filmed 'in cabin on open stage', according to daily production reports for February 1925. (Eddie Manson recalled that this cabin set was constructed outside because the main studio was entirely occupied by the dance-hall set.)[226] While the angle of our view differs depending on the version one is watching, the viewer effectively has a seat at the table and one continuous long take provides an intimate view of the Lone Prospector's impromptu solo tabletop performance. The shot is a play of contrasts both in scale as well as between light and dark. The difference between Chaplin's full-sized head and the two miniature dancing 'legs' made of forks and rolls is emphasised by his dark suit, which blends with the shot's dark background, setting off his white shirt-front and well-lit face just above the gambolling silverware. The lighting achieves a kind of 'black art' effect that visually conjoins the performer's head with little dancing legs.

The Hank Curtis cabin set dressed for the New Year's Eve dinner sequence, February 1925, © Roy Export Company Establishment, scan courtesy Cineteca di Bologna

Mordaunt Hall of the *New York Times* thought, the 'dance with the rolls ... reminds one of those caricatures with a huge head and a very tiny body'.[227] It also resembles a 'humanette' performance in which the puppeteer's head is perched above a headless marionette that is manipulated under the chin of the puppeteer. Conjoining a human face subtly modulating its features to a marionette body moving with rapid arcing movements creates a comical contrast of scale and expressivity. One such humanette delights Lon Chaney's character with its cavorting dance in the music-hall scene of *The Blackbird* (1926).

For Charles Silver, Chaplin's

> sublime grace in this sequence ... demonstrates beyond argument that the quintessence of film art has very little to do with vast technical resources or visual razzle-dazzle. Film, albeit the most mechanical of the arts, ultimately belongs more to human beings, to faces, than to machines.[228]

The Blackbird (1926)

The Gold Rush is a film that eschews machines, even machines that would have been available to prospectors who went North just before the turn of the twentieth century (like the motorised cable tramways used to get supplies across the Chilkoot Pass visible in some Gold Rush-era stereoscope cards, but not in Chaplin's 'exact replica, copied from stereoptican [*sic*] views of the original pass').[229] Unlike Alaska, *circa* 1898, there is no packaged food, no electrical communication and no motorised transportation to be seen in *The Gold Rush* until a steamship appears at the end of the film to spirit Big Jim and the Lone Prospector away. In this way, *The Gold Rush* offers a striking contrast with *Modern Times*, a film in which transportation, work and even food consumption, are fully mechanised.

Modern Times (1936)

14 Outtakes, Parallel Takes and a Triple Take

According to Jean Cocteau, Chaplin complained, 'The dance of the bread-rolls! That's what they all congratulate me on. It is a mere cog in the machine. A detail. If that is what they specially noticed they must have been blind to the rest!'[230] Likening the film to a machine, Chaplin objected to how this single 'detail' unfairly overshadowed the film as a whole. Whatever Chaplin's feelings were in 1936 (when he and Cocteau were on the same ship to the Far East), the dance of the rolls has only become more recognised since then. It is not just the most iconic performance in *The Gold Rush*, but in Chaplin's entire oeuvre, and it has been the object of numerous homages right up to the present day. Such homages isolate one of the cogs in Chaplin's film-machine. Even though Chaplin insisted that *The Gold Rush* was constructed from an ensemble of individual parts and that all of the gags in the film 'proceed directly out of the story', many of these parts function quite well apart from the Gold Rush narrative in which they are embedded. Siegfried Kracauer noted in a short essay on silent film comedy, 'Any such gag was a small unit complete in itself and any comedy was a package of gags which, in music hall fashion, were autonomous entities rather than parts of a story'.[231]

Chaplin assembled *The Gold Rush* from recognisable – sometimes even generic – components that could fit together more or less seamlessly in various ways. Thus, it could also be readily disassembled. Chaplin did just that in 1941, when he decided to tinker with the machine and give it what he felt was a needed tune-up. A film vault stacked with reels of interchangeable parts – that is, outtakes – facilitated Chaplin's tinkering, although he seems to have destroyed at least one of the 1925 negatives in the process. Like the alarm clock the little tramp tries to repair in *The Pawnshop* (1916), the 'machine' did not make it through the process intact. Whatever

'original negatives, fine grains and prints' of *The Gold Rush* (1925) that did remain were also later destroyed – like Josef von Sternberg's 1926 *The Sea Gull* (also known as *A Woman of the Sea*), which Chaplin produced and then ordered destroyed because he deemed it impossible to release and wanted the tax write-off from the loss.[232]

It is difficult to confidently say which parts of the many versions of *The Gold Rush* still in existence are 'original' to the film's 1925 release. Nearly all of the live-action shots we see were filmed in 1924–5, but how many of these shots were considered outtakes when the film was initially released? Some shots Chaplin originally designated as outtakes and consigned to the vaults were subsequently incorporated into the sound version, and more may have been conscripted for Rohauer's unauthorised versions of *The Gold Rush*. Since Chaplin was well known for continuing to shoot retakes long after everyone else on the set was ready to move on, some outtakes – apart from those containing outright gaffes or those shot for scenes

The Pawnshop (1916)

that were eventually omitted – would be indistinguishable from the takes Chaplin originally selected to include in the film.

A forty-page cutting continuity in the Chaplin Archive dated 1925 describes the 770 shots and gives the wording of the 150 intertitles Chaplin settled on at some point during the summer of that year for a ten-reel version of *The Gold Rush*.[233] Most of the takes that were filmed in the studio were assigned individual 'Scene' numbers, and the cutting continuity lists the 'Scene' numbers for each successive shot of the film to ease the process of negative cutting. But, because the numbering system was lost along with the additional footage from *The Gold Rush* discarded during the shutdown of Chaplin's studio (and because the provenance of surviving silent versions is so muddled), we do not know how much of what we see in various presently accessible versions corresponds to what Chaplin chose in 1925.

Josef von Sternberg with cast and crew shooting *The Sea Gull* on location, 1926

100 | BFI FILM CLASSICS

Friday - February 13, 1925.

Scene 3670.	Great Closeup - clock in window - time 2 minutes to 8 o'clock.	O.K. 30
Scene 3671.	Medium Closeup - Retake - C. C. leaving door after exit of mule - coming to table sitting down - lap dissolve into four girls sitting at table having party - C. C. doing dance with rolls on end of forks	O.K. 194
Scene 3672.	Retake.	O.K. 188
Scene 3673.	Continuation - retake after dance - Miss Hale puts arms around C. C. - kisses him - he falls back - Lap dissolve - finds C. C. asleep - head on arm - fade out.	N.G. 16
Scene 3674.	Retake.	O.K. 45
Scene 3675.	Retake.	N.G. 28
Scene 3676.	Retake.	N.G. 27
Scene 3677.	Retake.	O.K. 46
Scene 3678.	Medium Closeup - C. C. asleep on table wakes up - looks at clock - shakes it - winds it - hears music - goes to door - comes to table - looks - picks up hat and cane from bed - exits - fade out.	N.G. 54
Scene 3679.	Retake.	O.K. 194
Scene 3680.	Retake.	O.K. 207
Scene 3681.	Retake - Closeup - C. C. at table doing dance with rolls on end of forks.	O.K. 71
Scene 3682.	Retake.	O.K. 64
Scene 3683.	Retake.	O.K. 76
Scene 3684.	Retake.	O.K. 75
Scene 3685.	Retake.	O.K. 73
Scene 3686.	Retake.	O.K. 74
Scene 3687.	Retake.	O.K. 72
Scene 3688.	Retake.	O.K. 69
Scene 3689.	Great Closeup - C. C. & Miss Hale at table - C. C. bowing - Miss Hale showing presents - C. C. kisses hand	O.K. 38
Scene 3690.	Retake.	O.K. 41
Scene 3691.	Retake.	O.K. 45
Scene 3692.	Retake.	O.K. 46

228.

The register of scenes kept by Chaplin's production company logged multiple retakes of Chaplin 'doing dance with rolls' on 13 February 1925, from the archives of Roy Export Company Establishment, scan courtesy of Cineteca di Bologna

For example, according to the register of scenes for 12–13 February 1925, some eleven different takes of Chaplin 'doing dance with rolls' were filmed in close-up shots over these two days. The cutting continuity indicates that 'Scene 3683' was used for the Oceana Roll, but we do not know exactly what Scene 3683 looks (or looked) like, and most of the takes are approximately the same length. What are the differences between Scene 3683, which was filmed sometime on 13 February, and the outtakes – Scenes 3654–3656, 3681–3682, 3684–3688? All seem to have been permutations of a performance and all were shot in close-up. Additionally, since two cameras were used, there are (or were) also two parallel takes of Scene 3683. Chaplin's production company never parsed such differences of camera angle or cadence, but we may be able to see them when we compare different versions of *The Gold Rush* side by side, still unsure which of nearly two dozen takes of the Oceana Roll we are watching.

The sound version, *The Gold Rush* (1942), is the film that Chaplin left for posterity, but it will perhaps always be haunted by spectres of the several 'original' versions audiences saw in 1925. While the Lone Prospector picks up a torn photograph of Georgia from the floor of the dance hall, keeps it under his pillow and eventually frames it for his bedside table, we have no print of *The Gold Rush* (1925) to fetishise. If such a print does survive, would we

even be able to tell the difference? How would we know what is original and what is not? The memories of those who saw the film in 1925 will soon be gone, if they are not yet already long forgotten, like the location of Big Jim's secret mine.

Yet, memories can be deceptive, and watching different versions of *The Gold Rush* can induce both *déjà vu* and *jamais vu*. Have I seen exactly this before? Is the shot, scene or film I am watching somehow different from what I saw before? Like many in 1942 who saw the sound version of *The Gold Rush* some seventeen years after having seen a silent version of the film, the *New Yorker* critic relied on memory, writing,

early in the picture Charlie is shown wandering along a snowy trail followed by a bear. He looks around to see if anything is after him; just then the bear wanders into a cave and Charlie doesn't see him. In the original release, Charlie looked back three times. Now he looks back only once.[234]

The Gold Rush © Roy Export S.A.S., scan courtesy of Cineteca di Bologna

Really? Can that possibly be correct? If so, no such performed triple take survives or is recorded elsewhere. Either it is lost (like so much of the footage shot for *The Gold Rush*), or else it was never there 'in the original release' to begin with.

We should conclude by asking if there was ever anything truly 'original' in *The Gold Rush* – much less in any of the versions we can now see. The film's appropriations were multiple. So too were its variations, from the very beginning. *The Gold Rush* should remind us that authenticity is not just elusive, but perhaps entirely illusive, when it comes to technologically reproducible media. Like originality, authenticity is a judgment assigned more or less arbitrarily rather than a quality inherent in the work itself. Whatever these innumerable – and often not completely identical – copies of *The Gold Rush* may lack in so-called 'authenticity', still we laugh, so maybe it does not matter quite so much after all.

Notes

1 Herbert Jacoby, a lawyer representing Chaplin's estate, claimed, 'THE GOLD RUSH is and will, until 50 years after Chaplin's death, continue to be protected abroad in countries that are members of the Berne Convention'. Quoted in Bonnie McCourt, 'The Truth Police', *Limelight* vol. 1 no. 1 (1995), p. 15.
2 A company that distributed silent Chaplin shorts even circulated a version that had been cut to half an hour. Letter from Rachel Ford to Herbert Jacoby, 8 November 1978, Chaplin Archive, ECCI00313876. Other versions were as long as two hours.
3 David Pierce, *The Survival of Silent American Feature Films: 1912–1929* (Washington: Library of Congress, 2013).
4 I borrow this term from Paolo Cherchi Usai's comments in Paolo Cherchi Usai, David Francis, Alexander Horwath and Michael Loebenstein, *Film Curatorship: Archives, Museums, and the Digital Marketplace* (Vienna: Österreichisches Filmmuseum, SYNEMA – Gesellschaft für Film und Medien; Pordenone, Italy: Le Giornate del Cinema Muto, 2008), p. 29.
5 Quoted in 'New Chaplin Film Brings Supremacy', *Exhibitors Campaign Book for Charlie Chaplin in 'The Gold Rush'* (New York: United Artists, 1925).
6 Charles Spencer Chaplin, legal document, n.d. [1956–1977], Chaplin Archive, ECCI00313847.
7 'On the Set with Charlie, as Seen by Sid Grauman', *Charlie Chaplin in 'The Gold Rush'* (Los Angeles, CA: Sid Grauman, 1925).
8 [Daily production reports on *The Gold Rush*] (29 December 1923–31 October 1925), Chaplin Archive, ECCI00313697. Cited hereafter by date in the body of the text.
9 David Robinson, *Chaplin: His Life and Art*, rev. edn (London: Penguin Books, 2001), p. 225.
10 'Chaplin's "Gold Rush" Completed', *Variety* (29 April 1925), p. 24.
11 'Chaplin's Bull; Grauman Sore', *Variety* (17 June 1925), p. 26.
12 'Alaskan Film Sets Record', *Los Angeles Times* (12 July 1925), p. D20; Wally, 'The Gold Rush', *Variety* (1 July 1925), p. 32.
13 Lita Grey Chaplin and Jeffrey Vance, *Wife of the Life of the Party* (Lanham, MD: Scarecrow Press, 1998), p. 64.
14 'The Gold Rush', *Variety* (19 August 1925), p. 36.
15 Herbert Howe, 'Close-Ups and Long-Shots', *Photoplay* (September 1925), p. 66.
16 *The American Film Institute Catalog of Motion Pictures Produced in the United States, vol. F2, Feature Films, 1921–1930* (New York: R. R. Bowker Co., 1971), p. 302.
17 'Tuning "Gold Rush" for Holiday Reissue', *Variety* (15 October 1941), p. 6; 'Chaplin Promises New Surprises in "Gold Rush"; Sound Track for "Circus"', *Variety* (26 November 1941), p. 4.
18 '*The Gold Rush* – Revised', typescript, Chaplin Archive, ECCI00022537.
19 'Drama in Madison', *Capital Times* (26 April 1942), p. 25; 'Gold Search Film at The Esquire', *Oakland Tribune* (22 October 1942), p. 29; 'Chaplin-"York" Strong Dual for RKO in N.Y.', *Variety* (12 August 1942), p. 25.
20 Walter Kerr, *The Silent Clowns* (New York: Alfred A. Knopf, 1975), p. 314.

21 Alice Artzt, 'Charlie Chaplin: *The Gold Rush*', *Perfect Vision* (Indian summer 1987), p. 107.
22 Richard Schickel, 'Introduction: The Tramp Transformed', in Richard Schickel (ed.), *The Essential Chaplin: Perspectives on the Life and Art of the Great Comedian* (Chicago, IL: Ivan R. Dee, 2006), p. 36.
23 Jack Stillinger, *Coleridge and Textual Instability: The Multiple Versions of the Major Poems* (New York: Oxford University Press, 1994), p. 132.
24 Ibid., p. 124.
25 David Gill, '*The Gold Rush* 1925 – 1942 – 1993', *Griffithiana* no. 54 (1995), p. 125.
26 Ibid., p. 131.
27 Kevin Brownlow, personal communication with the author, 17 June 2014.
28 Compare *The Gold Rush*, The Chaplin Collection (Warner Home Video, MK2 Éditions, 2003), disc 2, and *The Gold Rush* (Criterion Collection, 2012). The latter also contains an informative audio commentary track by Jeffrey Vance.
29 See note 8, above; '"The Gold Rush" – re-issue: Weekly report sheets' [Weekly production reports] (21 June 1941–7 March 1942), Chaplin Archive, ECCI00313439. Cited hereafter by date in the body of the text.
30 Gill, '*The Gold Rush* 1925 – 1942 – 1993', pp. 123–31.
31 Jerry Lewis, *The Total Film-Maker* (New York: Random House, 1971), pp. 125, 158.
32 Ibid., p. 26.
33 Max Linder, quoted in Louis Delluc, *Charlie Chaplin*, trans. Hamish Miles (London: John Lane, 1922), pp. 34, 36.
34 'On the Set with Charlie, as Seen by Sid Grauman'.
35 Edward Sutherland, 'The Reminiscences of Albert Edward Sutherland', (1959), p. 46, in the Columbia Center for Oral History Collection, New York.
36 Ibid.
37 The programme for the Hollywood premiere of *The Gold Rush* claimed, however, 'the filming of "The Gold Rush" was started on February 7, 1924, with the final scenes taken on April 16, 1925', and tallied, 'Over five hundred thousand feet of film was used in the photographing.' 'The Making of "The Gold Rush"', *Charlie Chaplin in 'The Gold Rush'*.
38 'General Analysis of "The Gold Rush" – Production and Distribution', typescript, Chaplin Archive, ECCI00022535.
39 See Robinson, *Chaplin: His Life and Art*, p. 705n2.
40 Rudolf Arnheim, 'Who Is the Author of a Film?', in *Film Essays and Criticism* (Madison: University of Wisconsin Press, 1997), p. 62. Arnheim's essay was originally published in English translation in *Film Culture* (January 1958), pp. 11–13.
41 Robert Spoo, *Without Copyrights: Piracy, Publishing, and the Public Domain* (Oxford: Oxford University Press, 2013), pp. 3–4.
42 James Agee, 'Comedy's Greatest Era', in *Agee on Film: Criticism and Comment on the Movies* (New York: Modern Library, 2000), pp. 393–412. Originally published in *Life* (3 September 1949), pp. 70–82, 85–6, 88.

43 Iris Barry, 'Cinema: The Gold Rush', *Calendar of Modern Letters* (October 1925), p. 130.
44 Wally, 'The Gold Rush', p. 32.
45 Kathryn Morse, *The Nature of Gold: An Environmental History of the Klondike Gold Rush* (Seattle: University of Washington Press, 2003), pp. 138–42; Pierre Berton, *The Klondike Fever: The Life and Death of the Last Great Gold Rush* (New York: Alfred A. Knopf, 1958), pp. 196–200.
46 Jim Tully, *Beggars of Life: A Hobo Autobiography* (Garden City, NY: Garden City Publishing, 1924), p. 5; Jim Tully, 'Charlie Chaplin: His *Real* Life-Story,' part 3, *Pictorial Review* (March 1927), p. 54.
47 'Chaplin's Travesty – "The Gold Rush"', *Variety* (19 August 1925), p. 30.
48 Peter Decherney, *Hollywood's Copyright Wars: From Edison to the Internet* (New York: Columbia University Press, 2012), pp. 7–8.
49 Peter Decherney, 'Gag Orders: Comedy, Chaplin, and Copyright', in Paul K. Saint-Amour (ed.), *Modernism and Copyright* (Oxford: Oxford University Press, 2011), p. 136.
50 David Raksin, 'Life with Charlie', *Quarterly Journal of the Library of Congress* vol. 40 no. 3 (Summer 1983), p. 240.
51 Eddie Manson, 'Charlie Chaplin Secrets', 9, Edward Manson Collection, Margaret Herrick Library, Academy of Motion Picture Arts and Sciences, Beverly Hills, CA.
52 Joyce Milton, *Tramp: The Life of Charlie Chaplin* (New York: HarperCollins, 1996).
53 Robinson, *Chaplin: His Life and Art*, p. 167.
54 Milton, *Tramp*, pp. 120–3; Robinson, *Chaplin*, p. 155.
55 Ibid., pp. 156–7, 825.
56 Milton, *Tramp*, pp. 123–4; Decherney, *Hollywood's Copyright Wars*, p. 71.
57 Milton, *Tramp*, p. 124.
58 Tino Balio, *United Artists: The Company Built by the Stars* (Madison: University of Wisconsin Press, 1976), p. 57.
59 Charles Maland, *Chaplin and American Culture: The Evolution of a Star Image* (Princeton, NJ: Princeton University Press, 1989), pp. 62–93.
60 Ibid., p. 84.
61 David Robinson, *Chaplin: The Mirror of Opinion* (London: Secker & Warburg, 1983), p. 41.
62 Delluc, *Charlie Chaplin*, p. 14.
63 Viktor Shklovsky, *Literature and Cinematography*, trans. Irina Masinovsky (Champaign, IL: Dalkey Archive Press, 2008); Gerhard Ausleger, *Charlie Chaplin* (Hamburg: Pfadweiser Verlag, 1924).
64 Walter Benjamin, 'The Work of Art in the Age of Its Technological Reproducibility' (second version), in Michael W. Jennings, Brigid Doherty and Thomas Y. Levin (eds), *The Work of Art in the Age of Its Technological Reproducibility and Other Writings on Media* (Cambridge, MA: Belknap Press, 2008), p. 42. For a complete, critical edition of all of the versions, see Walter Benjamin, *Das Kunstwerk im Zeitalter seiner technischen Reproduzierbarkeit*, ed. Burkhardt Lindner with Simon Broll and Jessica Nitsche (Frankfurt a.M.: Suhrkamp, 2012).
65 Ibid., p. 28. Benjamin provided these same figures in a 1929 article, 'Chaplin in Retrospect', in *The Work of Art in the Age of Its Technological Reproducibility*, p. 336.

66 David Robinson, who based his calculations on Chaplin's production records, gives the shooting ratio for *A Woman of Paris* as 17:1 – not the 42:1 of Benjamin's figures. Robinson, *Chaplin: His Life and Art*, p. 827.

67 Rudolf Arnheim, *Film*, trans. L. M. Sieveking and Ian F. D. Morrow (London: Faber & Faber, 1933), p. 7. Benjamin cites the German edition in 'The Work of Art in the Age of Its Technological Reproducibility', pp. 47n22 and 51n27.

68 The daily production report for 19 February 1925 notes, 'Did not shoot. Mr. Chaplin at court – Chaplin vs. Aplin'. The *Los Angeles Times* reported that Chaplin testified in court again on the morning of 26 February 1925, although this was not noted in the daily production reports. 'Charlie Again Witness', *Los Angeles Times* (27 February 1925), p. A1.

69 'Charlie Chaplin Protests: Doesn't Want Anyone to "Ape" His Mannerisms, so Opposes "Charlie Aplin"', *Los Angeles Times* (8 March 1922), p. II10.

70 'Charles Amador Abandons Name of Charlie Aplin', *Los Angeles Times* (14 February 1925), p. 15.

71 'Chaplin-Amador Suit', *Variety* (20 August 1924), p. 17; 'Chaplin-Amador Suit Up', *Variety* (7 January 1925), p. 31; 'Aplin Will Call Chaplin', *Los Angeles Times* (26 February 1925), p. A2. 'Ralph Ray, old-time minstrel man was the first defense witness. He stretched his stage memory back to 1874 and declared the Chaplin character is "old stuff." He first saw Charlie's mustache in 1884, he said; the coat appeared also in the 80's the shoes and trousers were used by "every comedian in the business;" the flexible cane appeared in vaudeville in 1906'.

72 'Chaplin Pants Real Issue', *Los Angeles Times* (25 February 1925), p. A1.

73 'Film Trial Is Delayed by Flames', *Los Angeles Times* (20 February 1925), p. A1. On 24 February, however, 'Judge Hudner removed his court to an uptown projecting-room, where films of Billy West, mentioned in the case as an imitator of Chaplin, were shown' ('Chaplin Pants Real Issue').

74 'Unconscious While I Act', *Chicago Daily Tribune* (20 February 1925), p. 1.

75 'Aplin Will Call Chaplin', p. A2.

76 Jennifer Bean, 'The Art of Imitation: The Originality of Charlie Chaplin and Other Moving-Image Myths', in Tom Paulus and Rob King (eds), *Slapstick Comedy* (London: Routledge, 2010), p. 252.

77 'Amador Restrained from Aping Chaplin or Name', *Variety* (27 May 1925), p. 31.

78 'Challenges Title of Film Comedian', *Los Angeles Times* (20 May 1925), p. A1. '"We won", said Loyd Wright, attorney for Chaplin, yesterday. We won, echoed Isador [sic] Morris and Ben Goldman, counsel for Amador, making it unanimous'.

79 'Chaplin Legally Unique', *Los Angeles Times* (12 July 1925), p. B16; 'Chaplin Loses Fight on Exclusive Make-Up', *New York Times* (12 July 1925), p. E2.

80 'Chaplin Wins Imitator Suit', *Billboard* (11 August 1928), p. 13.

81 'Says Chaplin Took His Ideas', *New York Times* (30 October 1921), p. 34; 'Chaplin to Testify in Loeb's Film Suit', *New York Times* (6 May 1927), p. 20.

82 Additional depositions were reported taken in Los Angeles on 3 June 1924 in '"Shoulder Arms" Suit', *Variety* (4 June 1924), p. 22.
83 'Jury Disagrees in Suit over "Shoulder Arms"', *New York Times* (12 May 1927), p. 1; 'Jury Stood 10 to 2 against Chaplin', *Boston Globe* (13 May 1927), p. 16.
84 'Charlie Chaplin Wins Suit', *New York Times* (15 November 1927), p. 18.
85 Letter from Jean Sarment to Charlie Chaplin, 2 May 1931, Chaplin Archive, ECCI00007735; Milton, *Tramp*, pp. 318–19. In particular, the end of *City Lights* has certain striking similarities with the end of Sarment's *Les plus beaux yeux du monde*, which was performed in Paris in 1925 and then subsequently published and offered for sale to several Hollywood studios in an English translation.
86 Milton, *Tramp*, p. 366.
87 Ibid., pp. 383–5.
88 Letter from Alfred Reeves to Charles Millikan, 22 October 1940, Chaplin Archive, ECCI00019073.
89 Letter from Alfred Reeves to Arthur Schwartz, 22 June 1940, Chaplin Archive, ECCI00019081.
90 '3 New Jersey Actions', Chaplin Archive, ECCI00019046; letter from Arthur Schwartz to Alfred Reeves, 18 April 1941, Chaplin Archive, ECCI00019060; letter from Atwood C. Wolf to Charles Chaplin, c/o Schwartz & Frolich, 7 May 1941, ECCI00019054 Chaplin Archive.
91 Letter from Alfred Reeves to Loyd Wright, 13 November 1941, Chaplin Archive, ECCI00019147.
92 W. Ron Gard and Elizabeth Townsend Gard, 'Marked by Modernism: Reconfiguring the "Traditional Contours of Copyright Protection" for the Twenty-first Century', in Saint-Armour, *Modernism and Copyright*, pp. 165–8.
93 'Explanatory Circular No. 5 Subject: Dramas' (October 1922), Library of Congress.
94 Chaplin Archive, ECCI00317283.
95 Charles Spencer Chaplin, 'A Dramatic Composition in Three Acts Entitled The Gold Rush', 16 March 1925, Box 64, Copyright Deposit Drama Collection, Library of Congress.
96 Robinson, *Chaplin: His Life and Art*, p. 386.
97 Charles Chaplin, 'The Lucky Strike', 3 December 1923, Box 57, Copyright Deposit Drama Collection, Library of Congress.
98 Advertisement, *Film Daily*, 29 July 1923.
99 'Beery-Sills Fight in "The Spoilers" Reminds Veterans of Their Battles', *Washington Post* (8 July 1923), p. 2.
100 'Un nouveau film de Charlie Chaplin', *Cinéa-ciné pour tous* (1 August 1924), p. 9.
101 Robinson, *Chaplin: His Life and Art*, pp. 145–6.
102 Jeffrey Vance, *Chaplin: Genius of the Cinema* (New York: Harry N. Abrams), p. 157.
103 The version of 'The Gold Rush' that Chaplin copyrighted as an unpublished dramatic composition in March 1925 specifies the location of this city as Sitka. Chaplin, 'A Dramatic Composition in Three Acts Entitled The Gold Rush', p. 6.
104 Chaplin, 'The Lucky Strike'.

105 'Chaplin Finishing: Latest Picture Sets New Pace for Charlie', *Los Angeles Times* (23 April 1925), p. A9.
106 'Chaplin Changing Title', *Variety* (28 January 1925), p. 26.
107 'Chaplin's Next "The Gold Rush"', *Film Daily* (2 December 1923), p. 16.
108 'Chaplin's Next in September', *Film Daily* (30 March 1924), p. 2.
109 Jerry Kuntz, *A Pair of Shootists: The Wild West Story of S. F. Cody and Maud Lee* (Norman: University of Oklahoma Press, 2010), pp. 102–8, 113; Robinson, *Chaplin: His Life and Art*, pp. 46–66, 747–53.
110 'The Klondyke Nugget', 30 December 1898, Lord Chamberlain's Play Collection, Manuscripts Collections, British Library, London; John Simpson, *Days from a Different World: A Memoir of Childhood* (London: Macmillan, 2005), pp. 135–46.
111 Kuntz, *A Pair of Shootists*, p. 104.
112 Charles Musser, *Before the Nickelodeon: Edwin S. Porter and the Edison Manufacturing Company* (Berkeley: University of California Press, 1991), pp. 144–5.
113 *Edison Films Supplement* (February 1903), pp. 22–4, reproduced in *Motion Picture Catalogs by American Producers and Distributors, 1894–1908*, microfilm (Frederick, MD: University Publications of America, 1985), reel 1.
114 Oscar B. Depue, 'My First Fifty Years in Motion Pictures', in Raymond Fielding (ed.), *A Technological History of Motion Pictures and Television* (Berkeley: University of California Press, 1967), p. 62.
115 [Supplement to Charles Urban Trading Company 1906 catalogue], 25–28, reproduced in *Early [Rare British] Filmmakers' Catalogues, 1896–1913*, microfilm (London: World Microfilms, 1983), reel 6.
116 Andrew Sinclair, *Jack: A Biography of Jack London* (London: Weidenfeld & Nicolson, 1978), pp. 40–7.
117 Franklin Walker, *Jack London and the Klondike: The Genesis of an American Writer* (1966; San Marino, CA: Huntington Library, 1994).
118 Jack London, 'In a Far Country', *Klondike Tales* (New York: Modern Library, 2001), pp. 23–34. Originally published in *Overland Monthly and Out West Magazine* (June 1899), pp. 540–9.
119 Jack London, 'The Gold Hunters of the North', *Revolution and Other Essays* (London: Macmillan, 1910), pp. 190–1.
120 Jack London, *White Fang* (1906; New York: Macmillan, 1919), p. 202.
121 *Dictionary of American Regional English* (Cambridge, MA: Belknap Press, 1985–2012), vol. 1, p. 601; vol. 5, p. 136.
122 'Putting It Over', *Wid's Daily* (28 September 1920), p. 2.
123 'Producing in Alaska', *Film Daily* (11 May 1923), p. 1; 'Get Alaskan Picture', *Film Daily* (19 March 1924), p. 1.
124 John T. McManus, '"The Gold Rush" Glitters Like New', *PM* (20 April 1942).
125 Advertisement, *Film Daily* (6 April 1924), p. 3.
126 Hugh P. Rodman, 'Klondike Kit, or a Freeze-Out in the Chilkoot Pass', *Klondike Kit Library* no. 1 (New York: Street & Smith, 28 May 1898); Kathryn Morse, *The Nature of Gold: An Environmental History of the Klondike Gold Rush* (Seattle: University of Washington Press, 2003), pp. 145–6.

127 'Beautiful Snow-covered Locations Are Important Factor in Klondike Meller', *Wid's Film Daily* (1 June 1919), p. 2.
128 Advertisement, *Film Daily* (12 March 1922), p. 6; 'Good Acting and Gold Rush Story Make Satisfying Entertainment', *Film Daily* (16 July 1922), p. 7.
129 'Some Short Reels', *Film Daily* (16 July 1922), p. 13. The very same 16 July 1922 issue of *Film Daily* that contains reviews of *Belle of Alaska* and *Perils of the Yukon* also features full-page advertisements for *Jan of the Big Snows* (5) and *Nanook of the North* (9–10), suggesting just how ubiquitous the Northern film genre was at this time.
130 Mark Sandberg, 'California's Yukon as Comic Space', in Scott MacKenzie and Anna Stenport (eds), *Films on Ice: Cinemas of the Arctic* (Edinburgh: Edinburgh University Press, 2015).
131 Manson, 'Charlie Chaplin Secrets', p. 3.
132 Tully, 'Charlie Chaplin', part 3, p. 56.
133 '500 Skilled Men Worked on Movie', *Exhibitors Campaign Book for Charlie Chaplin in 'The Gold Rush'*.
134 Letter from Arthur Kelly to Sydney Chaplin, 11 June 1924, Chaplin Archive, ECCI00022334.
135 Advertisement, *Film Daily* (22 July 1923), pp. 6–7; Susan Orlean, *Rin Tin Tin: The Life and the Legend* (New York: Simon and Schuster, 2011), pp. 69–77.
136 'Movie Brown Bear Frolics in Snows', *Exhibitors Campaign Book for Charlie Chaplin in 'The Gold Rush'*.
137 'Chaplin on Stand Explains His Art', *New York Times* (10 May 1927), p. 25.
138 Lita Grey Chaplin, *My Life with Chaplin: An Intimate Memoir* (New York: Bernard Geis Associates, 1966), p. 61.
139 Chaplin, *My Autobiography* (New York: Penguin Books, 1964), pp. 299–300.
140 Richard J. Friesen, *The Chilkoot Pass and the Great Gold Rush of 1898*, *History and Archaeology* no. 48 (1981), p. 40.
141 One of the most frequently reprinted of these was issued by the Keystone View Company as part of a set of stereoscope cards representing the journey to the Klondike. See John P. Clum, *A Trip to the Klondike through the Stereoscope* (Meadville, PA: Keystone View Company); Robert E. King, 'Preserving and Interpreting the Gold Rush: The Unique Efforts of the Keystone View Company of Meadville, Pennsylvania', in *Preserving and Interpreting Cultural Heritage: Papers Given at the Annual Meeting of the Alaska Historical Society, Anchorage, Alaska, October 9–12, 1996* (Anchorage: Alaska Historical Society, 1997), pp. 84–97.
142 Chaplin, *My Autobiography*, p. 299.
143 Chaplin, *My Life with Chaplin*, pp. 58–73; Lita Grey Chaplin, *Wife of the Life of the Party*, pp. 34–8; Manson, 'Charlie Chaplin Secrets', pp. 3–8; Sutherland, 'The Reminiscences of Albert Edward Sutherland', pp. 57–63; Tully, 'Charlie Chaplin', part 3, pp. 22, 54, 56, 58.
144 'Charles Chaplin, Director-General', *Visions* (May 1924), p. 12.
145 Quoted in Grace Kingsley, 'Chaplin Finishing', *Los Angeles Times* (23 April 1925), p. A9.
146 Roland Totheroh, 'Roland H. Totheroh Interviewed: Chaplin Films', ed. Timothy Lyons, *Film Culture* nos 53–5

(1972), p. 239; Totheroh, quoted in Timothy J. Lyons, 'The Idea of *The Gold Rush*: A Study of Chaplin's Use of the Comic Technique of Pathos-Humor', in Donald W. McCaffrey (ed.), *Focus on Chaplin* (Englewood Cliffs, NJ: Prentice-Hall, 1971), p. 117.
147 Richard Meryman, 'Ageless Master's Anatomy of Comedy: Chaplin, An Interview', in Kevin J. Hayes (ed.), *Charlie Chaplin: Interviews* (Jackson: University Press of Mississippi, 2005), p. 140.
148 Lyons, 'The Idea of *The Gold Rush*', pp. 117–21.
149 '"Gold Rush" Produced by Charles Spencer Chaplin' [register of scenes], pp. 44–56, Chaplin Archive, ECCI00313695.
150 Ibid., pp. 73–7.
151 Vance, *Chaplin*, pp. 160–1; Jeffrey Vance, personal communication with the author, 3 May 2014.
152 Manson, 'Charlie Chaplin Secrets', p. 54.
153 Chaplin, *My Autobiography*, p. 300.
154 Robinson, *Chaplin: His Life and Art*, p. 810.
155 'Continuity: Charlie Chaplin in The Gold Rush', Chaplin Archive, ECCI00313858.
156 The dance hall has the same name as the legendary Dawson City saloon and variety theatre. See Tappan Adney, *The Klondike Stampede* (New York: Harper & Brothers, 1900), pp. 426–8.
157 Gerald Mast, *The Comic Mind: Comedy and the Movies*, 2d edn (Chicago, IL: University of Chicago Press, 1979), p. 100.
158 Ibid., p. 65.
159 Ibid.

160 Charles Beardsley, *Hollywood's Master Showman: The Legendary Sid Grauman* (Cranbury, NJ: Cornwall Books, 1983), p. 32.
161 Milton, *Tramp*, p. 225.
162 '"Gold Rush" Booked for Egyptian', *Los Angeles Times* (27 May 1925), p. A9; 'Chaplin's Bull', p. 26. Grauman was especially sore that the sneak preview took place just two days after he and Chaplin signed a contract to hold the world premiere at The Egyptian, and just five miles away, at The Forum, where spectators paid only sixty-five cents to see the film, while he was charging $5.50 for the premiere (advertisement, *Los Angeles Times* [19 June 1925], p. A11). Publicist Eddie Manson recalled arranging the sneak preview for Chaplin on very short notice (Manson, 'Charlie Chaplin Secrets', pp. 95–6).
163 '"Iron Horse" Closing', *Los Angeles Times* (14 June 1925), p. 19; 'Grauman's Egyptian', *Variety* (1 July 1925), p. 27; 'Commend "Gold Rush" Art', *Los Angeles Times* (2 August 1925), p. 20.
164 'Grauman's Egyptian', p. 27.
165 Playbill, Mark Strand Theatre, New York, 15 August 1925, Chaplin Archive, ECCI00007387.
166 Daily production report, 1 May 1925 (verso), Chaplin Archive, ECCI00313697.
167 Letter from Alfred Reeves to Sydney Chaplin, 23 May 1933, Chaplin Archive, ECCI00005434.
168 William M. Drew, *The Last Silent Picture Show: Silent Films on American Screens in the 1930s* (Lanham, MD: Scarecrow Press, 2010), pp. 57–8.

169 Letter from Alfred Reeves to Sydney Chaplin, 10 February 1934, Chaplin Archive, ECCI00005594.
170 Letter from Alfred Reeves to Arthur Kelly, 2 May 1938, Chaplin Archive, ECCI00018727.
171 Publicity document for *The Gold Rush* (1942), Chaplin Archive.
172 Rick Altman, *Silent Film Sound* (New York: Columbia University Press, 2004), p. 142, quoting W. Stephen Bush, 'Lectures for Moving Pictures', *Moving Picture World* (28 August 1908), pp. 136–7.
173 'The Gold Rush Revised 1942: Titles Script', Chaplin Archive, ECCI00313852.
174 Chaplin, *My Autobiography*, p. 250.
175 William Boehnel, 'Chaplin Back in Gold Rush Hilarity', *New York World Telegram* (20 April 1942).
176 *Hollywood* (August 1942); 'Chaplin Promises New Surprises in "Gold Rush"; Sound Track for "Circus"', *Variety* (26 November 1941), p. 9.
177 '"The Gold Rush", Old Charlie Chaplin Comedy, Is Revived at the Globe', *New York Sun* (20 April 1942).
178 Wanda Hale, 'Chaplin Back in "Gold Rush"', *New York Daily News* (19 April 1942).
179 Charles Musser, 'Work, Ideology, and Chaplin's Tramp', in Robert Sklar and Charles Musser (eds), *Resisting Images: Essays on Cinema and History* (Philadelphia, PA: Temple University Press, 1990), pp. 58–61.
180 Maland, *Chaplin and American Culture*, p. 207. See also p. 212.
181 Ibid., pp. 195–313.

182 Quoted in 'Charlie Chaplin's *Monsieur Verdoux* Press Conference', *Film Comment* (Winter 1969), p. 39.
183 André Bazin, 'L'Écran parisien: La Ruée vers l'or', *Parisien libéré* (16 December 1944), my translation.
184 André Bazin, 'Pastiche or Postiche, or Nothingness over a Mustache', in *Essays on Chaplin*, ed. and trans. Jean Bodon (New Haven, CT: University of New Haven Press, 1985), pp. 15–21. Originally published in *Esprit* (November 1945).
185 Rose Pelswick, 'Chaplin's "Gold Rush" Still Hilarious Film', *New York Journal-American* (20 April 1942); Archer Winsten, 'Chaplin's "The Gold Rush" Revived at Globe Theatre', *New York Post* (20 April 1942).
186 McManus, '"The Gold Rush"'.
187 Siegfried Kracauer, 'Silent Film Comedy', in Johannes von Moltke and Kristy Rawson (eds), *Siegfried Kracauer's American Writings* (Berkeley: University of California Press, 2012), pp. 213–17. Originally published in *Sight & Sound* (August 1951), pp. 31–2.
188 J. D. B., 'The Gold Rush', *Christian Science Monitor* (20 April 1942).
189 Gavin Lambert, 'As You Like It', *Sight & Sound* (July 1952), pp. 18–19.
190 'As the Critics Like It', *Sight & Sound* (October 1952), pp. 58–60.
191 *Confrontation des meilleurs films de tous les temps* (Brussels: Cinémathèque de Belgique, 1958); Louis Marcorelles, 'La confrontation de Bruxelles', *Cahiers du cinéma* no. 90 (1958), pp. 4–10.
192 John Gillett, 'The Best at Brussels', *Sight & Sound* (Winter 1958), p. 18.

193 Robinson, *Chaplin: His Life and Art*, p. 176.
194 Advertisement, *Variety* (3 February 1954), p. 42; 'Kling Studios Gets Chaplin Facilities', *Broadcasting-Telecasting* (21 December 1953), p. 34.
195 Paolo Cherchi Usai, *The Death of Cinema: History, Cultural Memory and the Digital Dark Age* (London: BFI, 2001), p. 66.
196 Robinson, *Chaplin: His Life and Art*, p. 176.
197 Raymond Rohauer, 'Rohauer's Story', in Kevin Brownlow, *The Search for Charlie Chaplin* (London: UKA Press, 2005), p. 173.
198 Rohauer, 'Rohauer's Story', p. 178. Although Brownlow writes, 'Most experts feel Rohauer was fabricating this story about restoring [sic] *The Gold Rush*' completely from outtakes (*Search*, 178fn38), it is difficult to conclude this with much certainty in the absence of a print of the 1925 version to compare with footage from *The Gold Rush* that can be traced to Rohauer.
199 Robinson, *Chaplin: His Life and Art*, p. 565.
200 1954 Rohauer Gold Rush copyright-Catalog of copyright entries. Ser.3 pt.12–13 v.13–15 1959–1961 Motion Pictures, LP13497.
201 'The Silent Empire of Raymond Rohauer', *Sunday Times* (19 January 1975).
202 'Defense of Chaplin Film Piracy', *Variety* (25 October 1961), p. 5.
203 'Chaplin Scores in Court over Illegal "Rush"', *Variety* (26 June 1963), pp. 17, 24; Gill, '*The Gold Rush* 1925 – 1942 – 1993', pp. 125–7.
204 'Chaplin Scores in Court over Illegal "Rush"', p. 17.
205 'Chaplin a Hit on N.Y. PTV Outlet', *Variety* (14 July 1971), p. 29.
206 *Feature Films on 8mm and 16mm*, comp. James L. Limbacher (New York: R. R. Bowker, 1977), p. 111.
207 Andre A. Blay, *Pre-Recorded History: Memoirs of an Entertainment Entrepreneur* (Centennial, CO: Deer Track Publishing, 2010), pp. 117–19; 'Chaplin Vidtape Rights Inclusive of "Paris" with Magnetic Video', *Variety* (26 April 1978), p. 32; Andre Blay, conversation with author, 9 December 2013.
208 'Chaplin on Revue', *Boxoffice* (September 1985), p. I-9; Kenneth Korman, 'Editor's Choice', *Video* (June 1994), p. 61.
209 Gill, '*The Gold Rush* 1925 – 1942 – 1993', p. 123.
210 Ibid., pp. 129–31.
211 David Robinson, 'One He Made earlier', *Times* [London] (3 November 1993).
212 Quoted in Grace Kingsley, 'Chaplin Finishing', *Los Angeles Times* (23 April 1925), p. A9.
213 Jean Moncla, 'Le cinéma', *La Revue hebdomadaire* no. 44 (31 October 1925), p. 625, my translation.
214 Iris Barry, 'The Cinema: Laughter-Makers', *Spectator* (18 September 1925), p. 444.
215 Ibid.
216 Chaplin, *My Life with Chaplin*, pp. 53–4.
217 Chaplin, *Wife of the Life of the Party*, pp. 38–9.

218 Edwin Schallert, 'Trick Photography in "The Gold Rush"', *Science and Invention* (December 1925), pp. 714–15.
219 M. W., 'The Movies', *Mercury* [London] (November 1925), p. 88.
220 Totheroh, 'Roland H. Totheroh Interviewed', p. 273.
221 Schallert, 'Trick Photography in "The Gold Rush"', p. 715.
222 Sutherland, 'The Reminiscences of Albert Edward Sutherland', p. 54. See also Vance, *Chaplin*, p. 156.
223 Ibid., p. 65.
224 J. P. Gallagher, *Fred Karno: Master of Mirth and Tears* (London: Robert Hale, 1971), p. 95, ellipsis in original.
225 Stan Laurel, quoted in John McCabe, *Charlie Chaplin* (Garden City, NY: Doubleday, 1978), p. 36.
226 Manson, 'Charlie Chaplin Secrets', pp. 62–4.
227 Mordaunt Hall, 'Pathos, Poetry and Farce Linked in Chaplin's Offering, '"The Gold Rush"', *New York Times* (23 August 1925), p. X3.
228 Charles Silver, *Charles Chaplin: An Appreciation* (New York: Museum of Modern Art, 1989), p. 23.
229 'Charles Chaplin, Director-General', p. 12. On motorised tramways, see Friesen, *The Chilkoot Pass and the Great Gold Rush of 1898*, p. 93.
230 Quoted in Jean Cocteau, *My Journey round the World*, trans. W. J. Strachan (London: Peter Owen, 1958), p. 109.
231 Kracauer, 'Silent Film Comedy', p. 32.
232 Josef von Sternberg, *Fun in a Chinese Laundry* (San Francisco, CA: Mercury House, 1965), pp. 32–3; Robinson, *Chaplin: His Life and Art*, pp. 407–10; Vance, *Chaplin*, p. 390.
233 [Continuity: Charlie Chaplin in The Gold Rush], Chaplin Archive, ECCI00313858.
234 'Goldrushiana', *New Yorker* (2 May 1942), p. 10.

Credits

The Gold Rush
a dramatic comedy
USA/1925

Director
Charlie Chaplin
Writer
Charlie Chaplin
Associate director
Charles Riesner
[credited as assistant director]
Assistant directors
Henri d'Abbadie d'Arrast
Edward Sutherland
[uncredited]
Photography
Rollie Totheroh
Camera operators
[uncredited]
Mark Marlatt
Jack Wilson
Art director
[uncredited]
Charles D. Hall

CAST
Charlie Chaplin
The Lone Prospector
Mack Swain
Big Jim McKay
Tom Murray
Black Larsen
Malcolm Waite
Jack Cameron
Georgia Hale
The Girl, Georgia

Henry Bergman
Hank Curtis

[from 'The Gold Rush 1925: Titles', typescript, Chaplin Archive, ECCI00313440]

Georgia's friends
[uncredited]
Kay Desleys
Joan Lowell
Betty Morrissey

Hollywood premiere at the Egyptian Theatre on 26 June 1925
9760 feet
New York premiere at the Mark Strand Theatre on 16 August 1925
8924 feet
Distributed by United Artists
8555 feet
London premiere at the Tivoli Theatre on 14 September 1925
Paris premiere at the Salle Marivaux on 22 September 1925
Copyright 1925 by Charles Chaplin

The Gold Rush
a revival of the silent picture,
with music and descriptive dialogue added
USA/1942

Director
Charles Chaplin
Narration
Charles Chaplin
Music
Charles Chaplin
Musical director
Max Terr
Sound recording
Pete Decker
W. M. Dalgleish
Film editor
Harold McGhan
Photography
Rollie Totheroh
Production manager
Alfred Reeves
Dedicated to Alexander Woollcott
In appreciation of his praise of this picture.

CAST
Charles Chaplin
The Lone Prospector
Mack Swain
Big Jim
Tom Murray
Black Larson
Henry Bergman
Hank Curtis
Malcolm Waite
Jack

Georgia Hale
Georgia

New York premiere at
the Globe Theatre on 18
April 1942
Hollywood premiere at
the Paramount Theatre
on 19 May 1942
6462 feet, 72 minutes
Copyright 1942 by
Charles Chaplin
Copyright renewed 1969
by Charles Chaplin

The Gold Rush
A restoration by
Photoplay Productions
Reconstructed by
David Gill
Kevin Brownlow
Patrick Stanbury
Negative cutting
Roy Weeks
Processing supervisor
Doug Massey

7740 feet
World premiere in
Liverpool on 29
November 1993
Copyright 1993 Roy
Export Company
Establishment

Select Bibliography

Agee, James, 'Comedy's Greatest Era', in *Agee on Film: Criticism and Comment on the Movies* (New York: Modern Library, 2000), pp. 393–412.

Arnheim, Rudolf, 'Who Is the Author of a Film?', in *Film Essays and Criticism* (Madison: University of Wisconsin Press, 1997), pp. 62–9.

Artzt, Alice, 'Charlie Chaplin: The Gold Rush', *Perfect Vision* (Indian summer 1987), pp. 103–12.

Bean, Jennifer, 'The Art of Imitation: The Originality of Charlie Chaplin and Other Moving-Image Myths', in Tom Paulus and Rob King (eds), *Slapstick Comedy* (London: Routledge, 2010), pp. 236–61.

Benjamin, Walter, 'The Work of Art in the Age of Its Technological Reproducibility' (second version), in Michael W. Jennings, Brigid Doherty and Thomas Y. Levin (eds), *The Work of Art in the Age of Its Technological Reproducibility and Other Writings on Media* (Cambridge, MA: Belknap Press, 2008), pp. 19–55.

Brownlow, Kevin, *The Search for Charlie Chaplin* (London: UKA Press, 2005).

Carroll, Noël, 'The Gold Rush', *Wide Angle* vol. 3 no. 2 (May 1979), pp. 42–9.

Chaplin, Charles, *My Autobiography* (New York: Penguin Books, 1964).

Chaplin, Lita Grey, with Morton Cooper, *My Life with Chaplin: An Intimate Memoir* (New York: Bernard Geis Associates, 1966).

Chaplin, Lita Grey, and Jeffrey Vance, *Wife of the Life of the Party* (Lanham, MD: Scarecrow Press, 1998).

Charlie Chaplin in 'The Gold Rush' (Los Angeles, CA: Sid Grauman, 1925).

Cherchi Usai, Paolo, *Silent Cinema: An Introduction* (London: BFI, 2000).

Decherney, Peter, *Hollywood's Copyright Wars: From Edison to the Internet* (New York: Columbia University Press, 2012).

Delluc, Louis, *Charlie Chaplin*, trans. Hamish Miles (London: John Lane, 1922).

Exhibitors Campaign Book for Charlie Chaplin in 'The Gold Rush' (New York: United Artists, 1925).

Garncarz, Joseph, *Filmfassungen: Eine Theorie signifikanter Filmvariation* (Frankfurt am Main: Peter Lang, 1992).

Gill, David, '*The Gold Rush* 1925 – 1942 – 1993', *Griffithiana* no. 54 (1995), pp. 123–31.

Kerr, Walter, *The Silent Clowns* (New York: Alfred A. Knopf, 1975).

Kracauer, Siegfried, 'Silent Film Comedy', in Johannes von Moltke and Kristy Rawson (eds), *Siegfried Kracauer's American Writings* (Berkeley: University of California Press, 2012), pp. 213–17.

Lewis, Jerry, *The Total Film-Maker* (New York: Random House, 1971).

Lyons, Timothy J., 'The Idea of *The Gold Rush*: A Study of Chaplin's Use of the Comic Technique of Pathos-Humor', in Donald W. McCaffrey (ed.), *Focus on Chaplin* (Englewood Cliffs, NJ: Prentice-Hall, 1971), pp. 113–23.

Maland, Charles, *Chaplin and American Culture: The Evolution of a Star Image* (Princeton, NJ: Princeton University Press, 1989).

Mast, Gerald, *The Comic Mind: Comedy and the Movies*, 2d edn (Chicago, IL: University of Chicago Press, 1979).

Milton, Joyce, *Tramp: The Life of Charlie Chaplin* (New York: HarperCollins, 1996).

Morse, Kathryn, *The Nature of Gold: An Environmental History of the Klondike Gold Rush* (Seattle: University of Washington Press, 2003).

Pierce, David, 'Copyright Lost', *American Film* (October 1985), pp. 68–70.

Robinson, David, *Chaplin: His Life and Art*, rev. edn (London: Penguin Books, 2001).

Saint-Amour, Paul K. (ed.), *Modernism and Copyright* (Oxford: Oxford University Press, 2011).

Sandberg, Mark, 'California's Yukon as Comic Space', in Scott MacKenzie and Anna Westerstahl Stenport (eds), *Films on Ice: Cinemas of the Arctic* (Edinburgh: Edinburgh University Press, 2015), pp. 136–49.

Schallert, Edwin, 'Trick Photography in "The Gold Rush"', *Science and Invention* (December 1925), pp. 714–15.

Schickel, Richard (ed.), *The Essential Chaplin: Perspectives on the Life and Art of the Great Comedian* (Chicago, IL: Ivan R. Dee, 2006).

Shepard, David, 'When Is a Film *the* Film?', *American Film* (March 1979), pp. 6–7.

Silver, Charles, *Charles Chaplin: An Appreciation* (New York: Museum of Modern Art, 1989).

Spoo, Robert, *Without Copyrights: Piracy, Publishing, and the Public Domain* (Oxford: Oxford University Press, 2013).

Stillinger, Jack, *Coleridge and Textual Instability: The Multiple Versions of the Major Poems* (New York: Oxford University Press, 1994).

Totheroh, Roland H., 'Roland H. Totheroh Interviewed: Chaplin Films', Timothy J. Lyons, ed., *Film Culture* nos 53–54–55 (1972), pp. 230–85.

Tully, Jim, 'Charlie Chaplin: His Real Life-Story', 4 parts, *Pictorial Review* (January 1927), pp. 8–9, 29–30, 32, 34; (February 1927), pp. 19–20, 72, 75; (March 1927), pp. 22, 54, 56, 58, 63–4; (April 1927), pp. 22, 106, 108.

Vance, Jeffrey, *Chaplin: Genius of the Cinema* (New York: Harry N. Abrams, 2003).

Unpublished sources

Chaplin, Charles Spencer, 'A Dramatic Composition in Three Acts Entitled The Gold Rush', 16 March 1925. Box 64, Copyright Deposit Drama Collection, Library of Congress, Washington.

Chaplin, Charles, 'The Lucky Strike: A Play in Two Scenes', 3 December 1923. Box 57, Copyright Deposit Drama Collection, Library of Congress, Washington.

[Cody, S. F.], 'The Klondyke Nugget', 30 December 1898. Add MS 53674 F, Lord Chamberlain's Play Collection, Manuscripts Collections, British Library, London.

[Daily production reports], 29 December 1923–31 October 1925, Charlie Chaplin Archive, ECCI00313697.

'"Gold Rush" Produced by Charles Spencer Chaplin' [register of scenes], 8 February 1924–14 May 1925, Chaplin Archive, ECCI00313695.

'"The Gold Rush" – re-issue: Weekly report sheets' [weekly production reports], 21 June 1941–7 March 1942, Chaplin Archive, ECCI00313439.

Hale, E. Hunter, '"The Gold Rush" log', 1989.

Manson, Edward, 'Charlie Chaplin Secrets'. Edward Manson Collection, Margaret Herrick Library, Academy of Motion Picture Arts and Sciences, Beverly Hills, CA.

Sutherland, Edward, 'The Reminiscences of Albert Edward Sutherland' (1959), Columbia Center for Oral History Collection, New York.

BFI Film and TV Classics

Have you read them all?

Each book in the BFI Film and TV Classics series honours a landmark of world cinema and television. With new titles publishing every year, the series offers some of the best writing on film and television available today.

Find out more about this series at **www.palgrave.com/bfi**

palgrave